MICHAEL CARROLL

Picturing the Possible

The Story of Romanian Children's Relief

It was a pleasure to meet both of you! Hope to see you again

Best

Mike Carroll

IMPRESS

To my wife, Joan, and my children, Devon and Brendan,
without whose patience, love, and support this project
would not have been possible.

PICTURING THE POSSIBLE: THE STORY OF ROMANIAN CHILDREN'S RELIEF

Photographs ©2010 Michael Carroll
Text by Michael Carroll with Laurence Sheehan
www.michaelcarrollphotography.com

ISBN 978-1-4507-0146-4

Designed and produced by Hans Teensma, Impress
www.impressinc.com
(Im)

Printed in the U.S.A. by The Studley Press

For information on Romanian Children's Relief contact
www.rcr.com www.inocenti.org

ROMA VILLAGE, TAGU, 2008

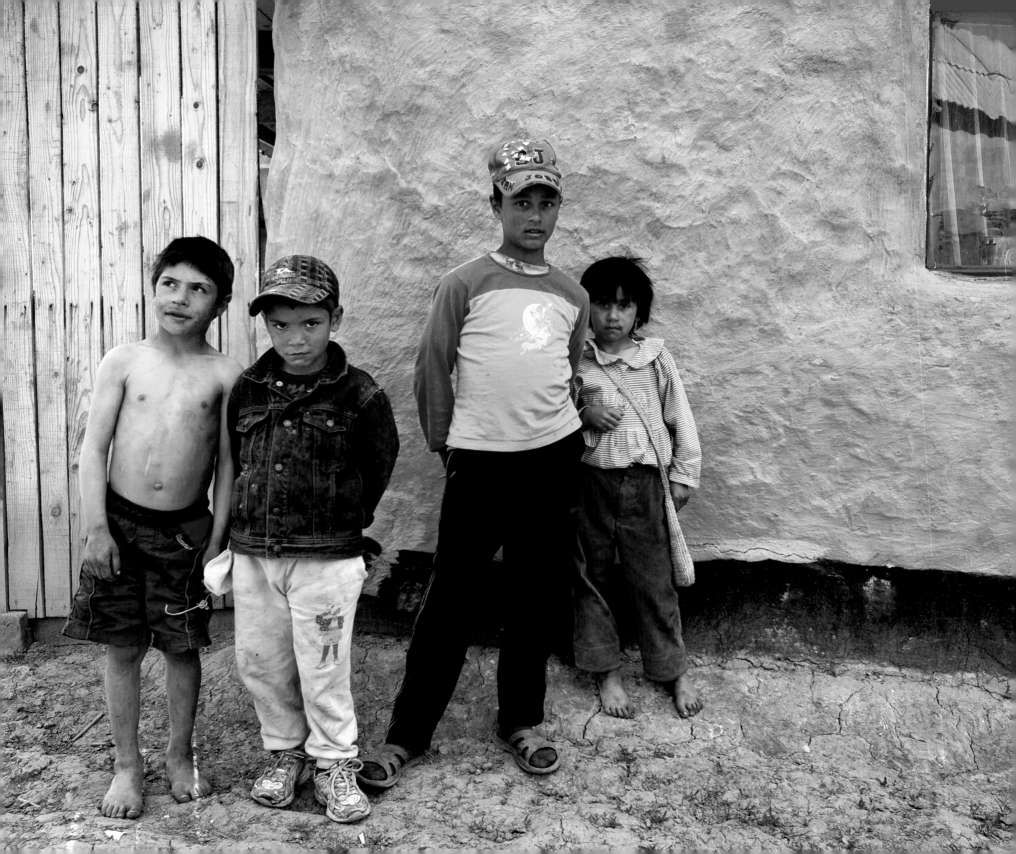

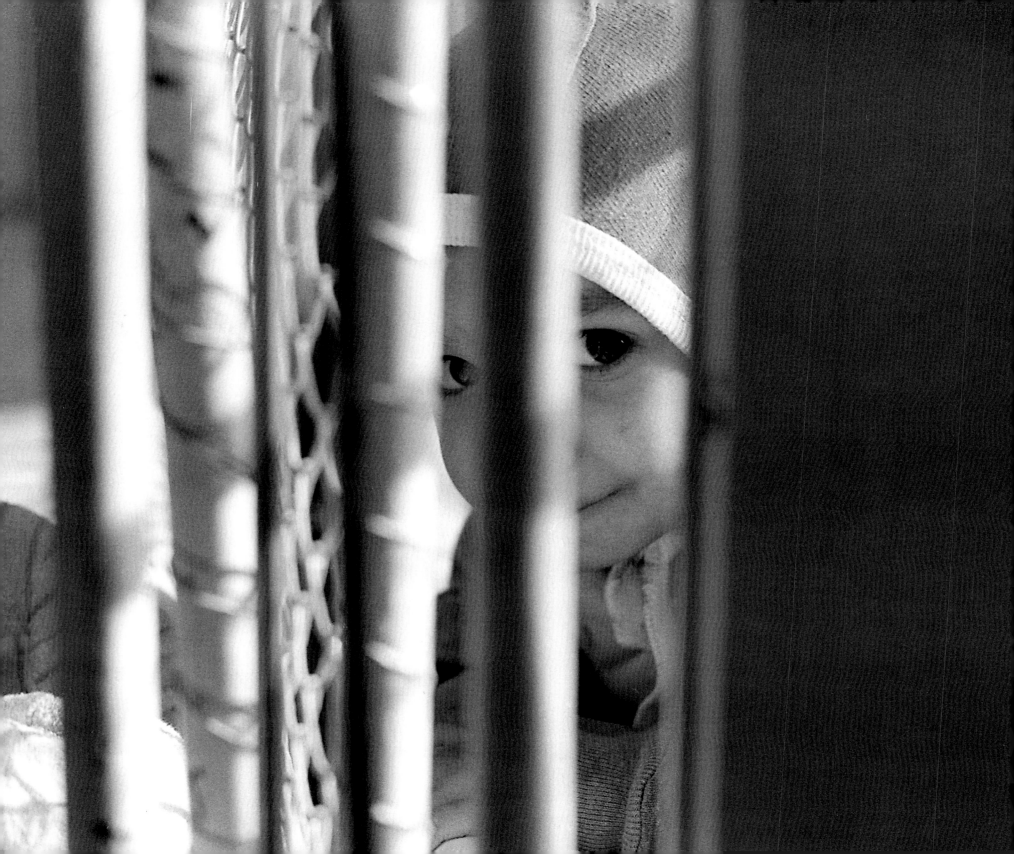

Prologue 8

1. In Country 16

2. Regime from Hell 23

3. Romania's Abandoned Children 37

4. Requiem for Gabriel 53

5. Babies in a Basket 63

6. The Foster Care Solution 73

7. A Bridge to Somewhere 85

8. Gypsies and Strawberry Orphans 93

9. Back to the Future 103

Epilogue 138

Acknowledgments 142

Prologue: August 25, 2004

IT WAS A WEDNESDAY MORNING in August, bright and sunny and crisp-aired, the essence of summer in New England. But I was not outside enjoying the weather. I was inside, placing the finishing touches on some large prints of golf scenes that were due to be hung as a special exhibit in the Massachusetts Golf Hall of Fame. In the course of more than a year I had taken hundreds of pictures of golf courses throughout the state for a book on the history of the game. I had picked some of my favorite images for the current project—a solitary golfer headed down a fairway framed by a brilliant rainbow; an older gent walking off the green of a links course on Cape Cod, while a thousand sea-birds flocked in circles overhead; two kids waiting to tee off on a course in the Berkshires.

I had one more print to mat up and frame before the job would be ready for delivery to the Massachusetts Golf Association, founder and operator of the hall of fame. I was excited about the prospect of seeing the pictures together in a gallery. As it turned out, those pictures never got there.

A smoke alarm went off below me. I hesitated, bent over a worktable, still absorbed in my task. Two weeks ago the same smoke alarm had sounded, but without cause. Now I figured it had to be another false alarm. My studio and all the equipment in it were brand-new. Built as a barnlike addition to our residence, to which it was connected by an ell, the studio had opened for business less than three months ago. It occupied three levels. On the first floor was a capacious open space suitable for photo shoots and an exhibit area itself. Midway up the stairs was space for my office, a conference area and several worktables. On the top level was a state-of-the-art computer workstation suite and my extensive picture archive, representing two decades of my work as a professional photographer.

The smoke alarm continued its shrill message of warning. I knew I had no choice but to investigate. I put down the golf print and descended the stairs to the first level. I saw at once that smoke was curling up through an air intake grate on the floor. I flung open the basement door and rushed down the stairs. I smelled some smoke, but not to a degree that I felt threatened.

I went to inspect the furnace that my contractor had installed for heating and cooling the new addition. It was hooked up to the natural gas pipeline that ran through our town. I'd insisted on buying one of the more expensive models because it had a feature for filtering out the particulate matter that furnaces normally release into the air while in operation. The filtering mechanism used low-voltage current to ionize the dust particles that would otherwise circulate through the air, find ways to cling to film, and drive photographers crazy.

I could see flames in the device through an opening normally covered by a small door, which apparently had blown open and was hanging by a hinge. This was decidedly abnormal. With a new sense of urgency, I raced to the basement's steel bulkhead doors, pushed them open and emerged in our backyard. I dashed into the kitchen and made a quick call to 911. Then I returned outside. I grabbed my garden hose, turned on the faucet, and dragged the hose, spewing water, behind me as I retraced my steps into the basement.

Big mistake. After striding into the basement merely ten or twelve feet, I was suddenly engulfed in black smoke. Unwittingly, I inhaled. The smoke scorched my throat and filled my lungs. The pain from the heat within my chest was like nothing I'd ever experienced. I dropped the hose. I could see nothing around me. My eyes burned. I was so disoriented I couldn't even figure out the direction I had come from.

A lesson from some dramatic firefighting scene in a movie or on television must have crossed my mind. I dropped to my knees, realizing the lower I got, the better would be my chances of finding air and actually seeing something. And indeed, I did catch a glimpse of light from the bulkhead entry in the distance. First I crawled toward it, then I rose and charged up the stairs, into the open air.

By a remarkable coincidence, the fire chief was at the town hall, which is only a block from my house, when my emergency call came in. He was on the scene, literally, within ninety seconds of my call. Our house is set back from the road some 150 feet. I had reported a furnace fire. When he pulled up, he could see from the street that flames were darting out of the studio windows in my new addition. He immediately called to upgrade the emergency from a furnace fire to a three-alarm structure fire.

The town of Pepperell, where I live, like most small towns in America, depends on volunteer firefighters for protection from fire and other emergencies. One of the first volunteers to arrive went into the basement to investigate and quickly retreated before the smoke, as I had done. Together we entered the main house, which also had begun to fill with smoke. We crawled across the kitchen floor as I led him to the entry to the house basement where the circuit breakers were located. He raced down the stairs and turned off the main breaker.

Other volunteers with oxygen packs on their backs descended on the property from all points, some in their own pickup trucks and SUVs, others in fire engines from Pepperell and surrounding towns. It was organized chaos, and I was in a daze. My mouth still tasted of smoke, and my chest ached.

Friends and neighbors showed up. My wife, Joan Peterson, was in the middle of an educational conference in the town of Harvard and couldn't be reached by phone, so Gregg Plummer, who owned the house next door to ours, offered to drive to Harvard and bring her back. My long-time friend Gary Morton, known to one and all as "Mort,"

notified my son, Brendan, who lived in Worcester and often helped me on photo shoots. My daughter, Devon, was at school in Maine, a sophomore at Bates College, and we decided to postpone telling her.

I feared we were on the verge of calamity. Smoke had begun rolling in even greater volume from the studio building through the ell and into the main house, and I felt sickened at the thought. Windows in the studio building starting blowing out, and I heard explosions, possibly caused, I thought, by flames reaching the battery packs I used when I needed to illuminate subjects for my photography. I learned later that at the peak of the fire, the temperature inside the building reached 1,400 degrees Fahrenheit.

My neighbor Andrea Dazzi rescued our parakeet, cage and all, from the kitchen—a random act of kindness one might expect from a dedicated yoga instructor. Firemen found our two cats under a bed on the upstairs floor of the main house and got them out safely, although they would both die within the year, their respiratory systems compromised by smoke inhalation.

When paramedics learned I too had been exposed to smoke, they insisted on taking me to the hospital, where I could have oxygen levels in my blood checked. The fire was still in its early stages and far from being under control, but they would not permit me to stay at the scene. My health was more important to them than my property. They put me on a stretcher, clapped an oxygen mask on my face, and rolled me into their EMT truck. The last thing I saw, looking upside down at my studio, was fire licking up the wall.

The drive to Deaconess Hospital in Ayer took about fifteen minutes. It felt like fifteen hours. I knew enough about house fires to understand why victims seek to save two things first and foremost among all their worldly possessions from a burning building—their pets and their photos. And that was now my preoccupation. Periodically, approaching busy intersections, the EMT driver turned on his siren, and that would startle me into the present, but then my mind would drift back to the fire.

We'd gotten the bird and the cats out of danger, but my pictures were another story. Even then I probably knew there was no hope for the survival of my carefully matted and framed golf prints. Some of my other film had been properly cataloged and filed in the photo archive. However, I had only recently moved my operation into the new quarters. Much of the film and slides had not been placed in proper storage boxes yet, but were sitting out on tables and workbenches. Would the firemen be able to save that part of the building? And if by chance the flames didn't reach the archive, what about the smoke? Or the water? It was common knowledge that the volume of water required to subdue a blaze could be as ruinous to property as the fire itself. I was reminded of the telling comment that made the rounds during the Vietnam War: "We had to destroy the village to save it."

I didn't have an exact count on the amount of film the archive contained, but more than twenty years' worth of magazine assignments, book projects, commercial jobs for hospitals, architectural firms, high-tech corporations, and assorted other ventures tend to make the 35mm slides and the 2¼" and 4x5" transparencies pile up. (In the predigital age, photographers worked in various formats and sizes, depending on the assignment.) Brendan once calculated that we had 400,000 images under wraps.

And a lot of the film still had significant monetary

value. Because I own the rights to the film I have shot, I have been able to supplement my income by reselling images in various markets.

I shuddered to think what the financial loss might be, should the entire archive be lost.

Another burst of the siren brought me back to earth. I thought of all the pictures I had taken of Romania, a country I could not have located on a map before my first visit there in 1990. In my role as a photojournalist at that time, I had captured children in such hideous conditions in their orphanages and hospital wards that the images I brought back to America brought tears to the eyes of people I showed them to.

But I had made many trips to Romania since that time and I had found beauty in a country which had long known only evil. The rugged beauty of the Carpathian Mountains, which zigzag through the countryside like a lightning bolt. The tranquil beauty of Transylvanian farms and fields. The ethereal beauty of painted churches and remote monasteries. The stoic beauty of the peasants, in whose faces are etched centuries of rural habits and traditions.

And the innocent beauty of the children of Romania, some healthy and happy, some not so healthy or happy.

In particular, as the ambulance bore me to Ayer, there came to mind a homeless girl who had lived in a sewer under the train station in Bucharest before finding a better situation by joining a street circus. This was a band of homeless children trained by a professional clown from France to perform as jugglers, mimes, and acrobats in public parks and squares in that city. I did a story on the street circus for *Reader's Digest Europe*. I had photographed the girl with the Polaroid camera I carried around expressly for this purpose. I took pictures of children and then gave the Polaroid prints to them. I never met a child who failed to accept this gift of his or her portrait with gratitude and even glee.

The homeless girl in the Bucharest sewer was like that. Her tattered purse contained her cigarettes and her Polaroids and nothing more.

There may have been as many as 10,000 images of Romania in my picture archive in the studio building. Unlike most of the photos I had shot commercially, these pictures had emotional value for me. If they had gone up in flames with all the rest, I realized now, those images, along with the photos I had taken of my family over the years, would be the ones I would miss the most. For Romania had changed me over the years, as it had changed my family, and had helped me find my better self. And maybe that would help me survive the dawning reality of the present crisis.

At least that's what I hoped, as we turned into the driveway for the emergency room in Ayer, siren wailing.

(FOLLOWING SPREAD) CEAUŞESCU'S "PALACE OF THE PEOPLE," NOW KNOWN AS PALACE OF THE PARLIAMENT, BUCHAREST, 2008

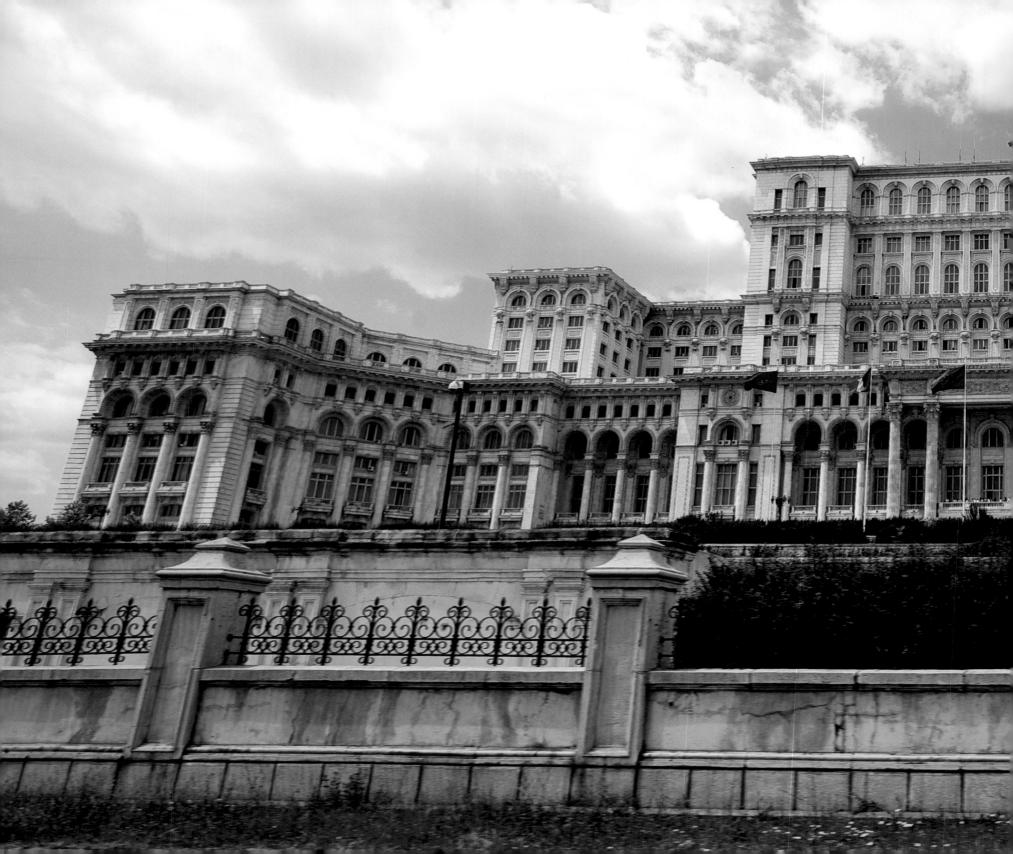

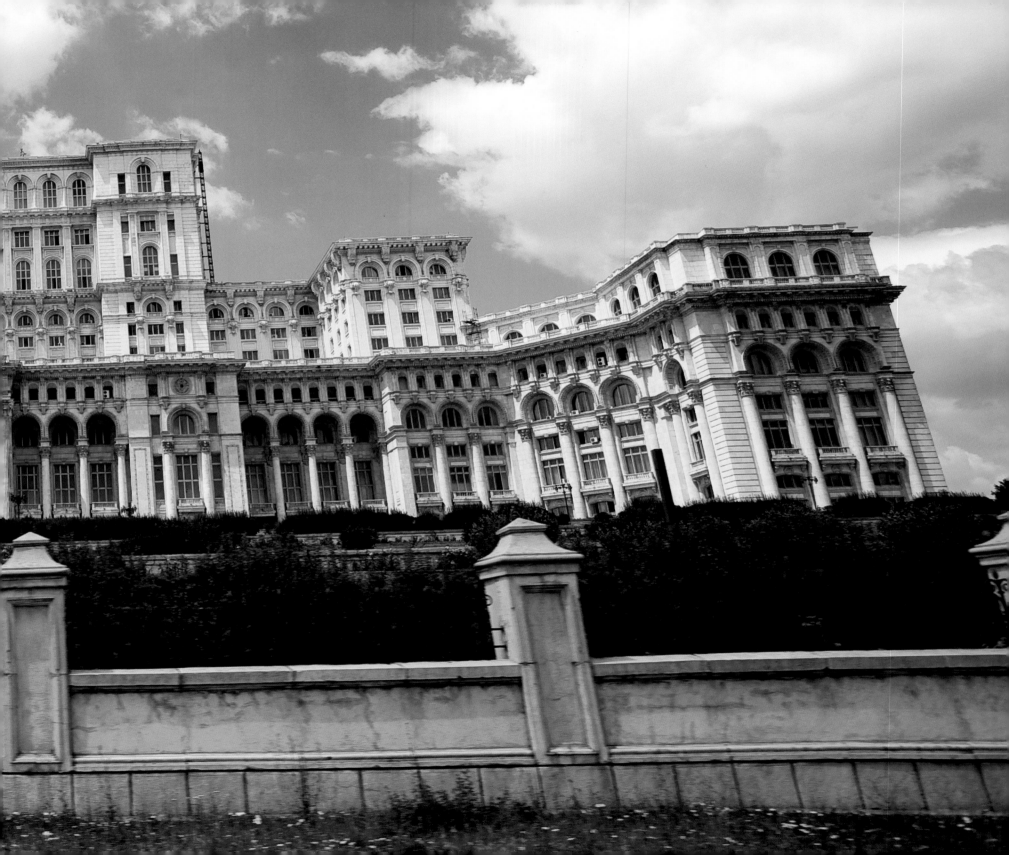

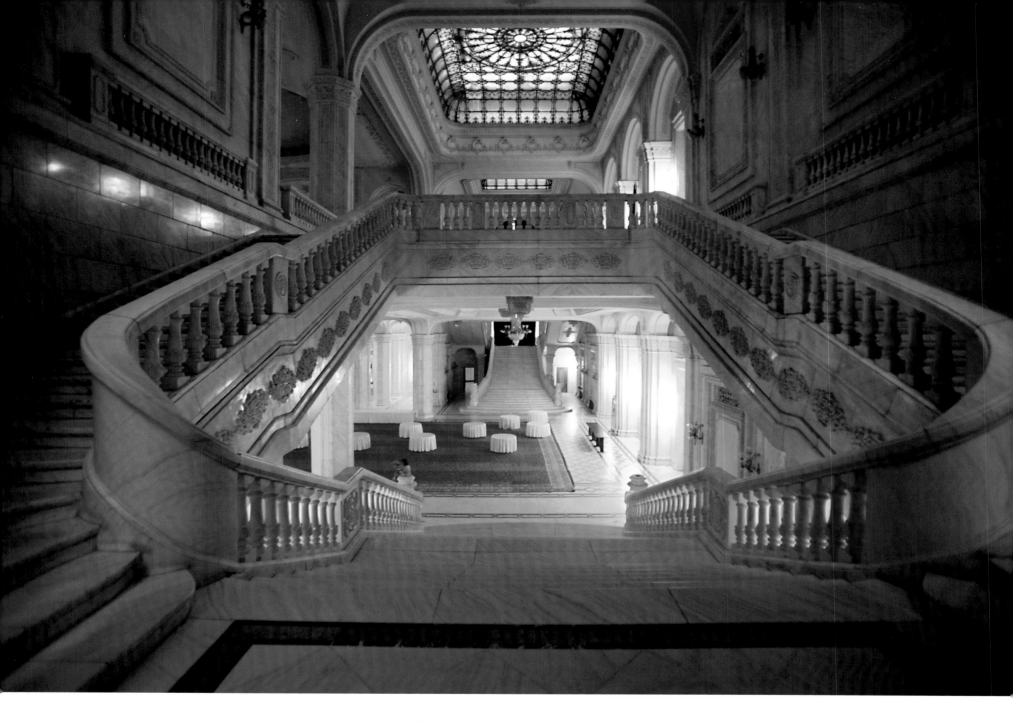

STAIRWAY, PALACE OF THE PARLIAMENT, BUCHAREST, 2008

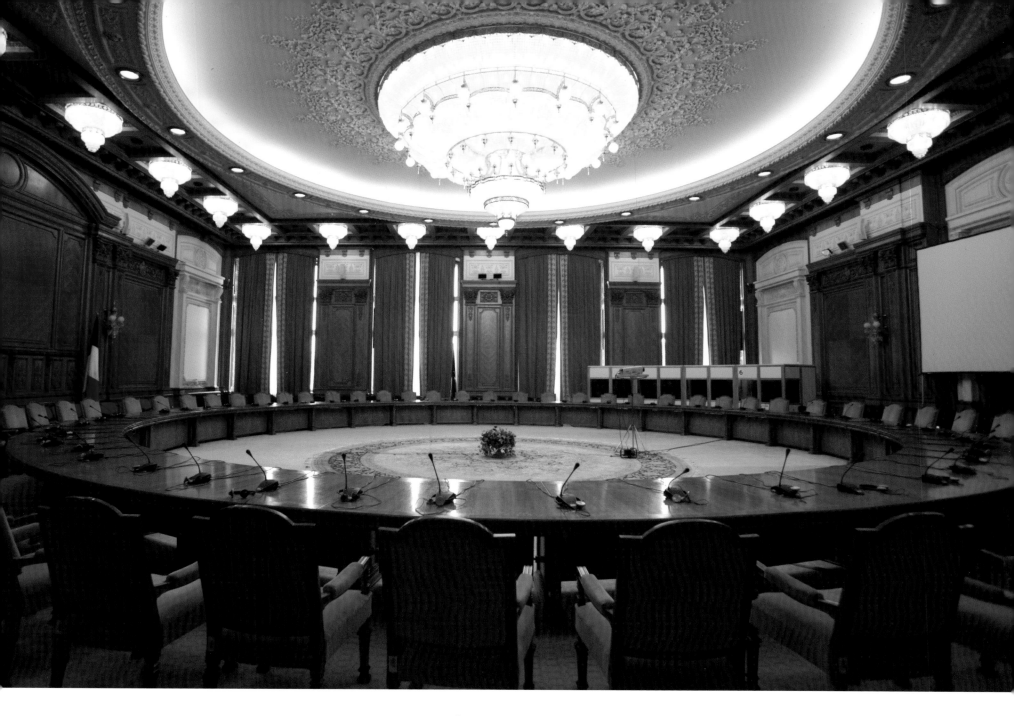

CONFERENCE ROOM, PALACE OF THE PARLIAMENT, BUCHAREST, 2008

1. In Country

WHEN I TURNED THIRTY, I took a canoe trip with some friends on the St. John River along the border between Maine and Canada. At the time I was working for a nonprofit group called the Nashua River Watershed Association. Headquartered at Fort Devens—a sprawling military reservation outside of Boston and now rehabbed as a high-tech industrial park—the group's mission was to push through provisions of the Clean Water Act in our state. For example, we worked with towns along the Nashua River, which happens to run through Pepperell, where my wife, Joan, and I lived, to create more open space and forestall further development along the waterway. Paper mills and plastics plants had dumped toxic materials into the Nashua for a hundred years or more. Septic waste from homes and factories and chemical fertilizers used on farms had been allowed to pollute the river as well.

In the pristine Maine wilderness, by contrast, I was floating along on a river that did not stink—a healthy body of water of surpassing natural beauty. Perhaps inspired by this setting, it seemed important at the time for me to reflect on where I had been in my life and, more important, where I was headed. A thirtieth birthday tends to induce sober thinking of this sort. At least it did in my case.

As much as I supported the goals of the watershed association, I knew I did not want to work there forever. (Mostly, I handled publicity in the two years I was with the group.) I reflected on the motley assortment of jobs I'd held since graduating from Notre Dame. I'd taught seventh grade in an inner-city school—P.S. 40—in Jersey City, New Jersey, for two years. I'd found teaching to be challenging and rewarding, but hardly lucrative. For another kind of challenge, I drove a cab in New York City—nights. I painted houses in the summer. For a time, without a shred of credentials for the job, I was the movie reviewer for the *Harvard Post*, a small-town newspaper in eastern Massachusetts. (My film reviews have not yet been collected and reissued.)

I worked in a photo shop for a time as a salesperson catering to amateur photographers, who were the shop's primary customers. I already knew a little about photography from a

course I'd taken while at Notre Dame, renting a friend's camera for $10, I remember, so I could do the homework I was assigned. Actually, the course was given at nearby St. Mary's College. This took place at a time when I was busy working as a volunteer in the presidential primary campaign of Senator Eugene McCarthy ("Clean for Gene!"). As a result, I missed so many of the classes that I failed to receive credit for taking the course. (I also failed to meet the girls I was told would be falling all over me in photo class at the all-women school.) I did learn Ansel Adams' darkroom technique of "exposing for the highlights and developing for the shadows."

Modest beginnings, to be sure, but there was something about photography that called to me during that trip on the St. John. When I got back from Maine, the first thing I told Joan was that I was quitting my job. The second thing I said was that I was going to be a photographer.

Joan, who was pregnant with our first child at the time, looked at me and said, "Are you crazy?"

"About the quitting, you mean?" I asked. "Or about the photographer part?"

She didn't have to answer. I knew that both decisions were crazy.

But I also knew they were absolutely right.

On my first trip to Romania, in February of 1990, I was part of a team put together by AmeriCares, a nonprofit relief group based in the United States, to investigate rumors of an AIDS epidemic that was reported to have broken out among children in Romanian hospitals. After flying to Budapest, I linked up with the team: a doctor, relief workers, and several Hungarian linguists who would serve as our translators in country. We met at a church that had famously served as an underground railroad stop during the Cold War, clandestinely shuttling anticommunist East Germans to Austria and freedom. We piled into a van and Range Rover belonging to the Knights of Malta, emblazoned with red crosses on their sides, for the first part of our journey.

The Berlin Wall had fallen on November 7, 1989. Nicolae and Elena Ceauşescu, the demonic duo who had ruled the Socialist Republic of Romania to ruinous effect since 1965, had been executed on December 25, 1989, following a military coup and kangaroo court. The winds of change were being felt throughout Eastern Europe. We were traveling into a brave new world, seemingly, and yet much that lay ahead was neither brave nor new.

We spent our first night together in a hotel in the border town of Debrecen. We were hungry, but the dining room in the hotel was closed. There was no other place to eat, so I checked into my room, resigned to going to bed on an empty stomach. Ten minutes later the fellow who had carried my bags up to my room reappeared. He signaled for me to come with him. I was a little suspicious of his motives, but I followed him downstairs and then outside the hotel through a back door. A truck was parked in the street. A guy standing next to it, a Russian, I learned, was selling caviar out of the back of the truck.

So for my evening meal, I dined on beluga caviar from the Caspian Sea. New York's famed Russian Tea Room could not have treated me better.

The following morning we headed for the border. We had to wait in line for hours, first on the Hungarian side, then on the Romanian side, to be processed. By the time we were cleared to actually drive into Romania, it was evening. The first town we came to, Oradea, gave a hint of the living

conditions in the country. Oradea was dark—no street lights, no traffic lights, few if any lights in the buildings we passed. As we soon found out, Romania's power grid was inconstant and unpredictable. Much of the country went without electricity for hours at a time. Glancing out the van window, I could barely discern human figures moving along on the sidewalk. They were like shades.

We left Oradea and headed for Cluj-Napoca and for our first glimpse of conditions inside a Romanian hospital.

A chance meeting had given me the opportunity to go on that first of many trips I made to Romania. The month before, I had traveled to Connecticut to photograph Bob McCauley, the head of AmeriCares, for a new magazine being published by *Inc.* Called *The Inc. Life*, it carried features on the nonbusiness activities and experiences of successful executives. While I was shooting McCauley for the magazine, I asked him about the challenge of delivering aid to Third World countries, and suggested that a story about his organization's efforts to bring relief to disaster areas would make interesting reading. He agreed, and we left it that he would get in touch with me the next time his group made a trip abroad.

After finishing the shoot with McCauley, I was going to New York to attend a party for *Travel & Holiday*, another magazine I worked for frequently. At this time I was also a regular contributor to *Yankee* and *Forbes*. But it had not been easy getting started. During the first year after I quit my job with the watershed association, Joan and I basically went through all our savings just to stay afloat. The first significant commission I landed was to photograph products for a furnace manufacturer. (Little did I know a

malfunctioning furnace would play havoc with my life and career years later.) Then I got wind of a magazine start-up called *New England Monthly*, and I drove to Williamsburg, in western Massachusetts, to meet the editor, Dan Okrent. I was so naïve about publishing that I didn't realize photographers were supposed to approach art directors, not the top editors, with their story ideas, and they were supposed to bring along their portfolios to show examples of past work. I didn't even know what a portfolio was.

For all my shortcomings, it turned out that Okrent liked two of my story ideas—one about teenagers training for military combat at Fort Devens, the other about a dangerous wilderness route used by logging trucks in Maine called the Golden Road. He introduced me to his art director, Hans Teensma, who then went on to design *The Inc. Life* that sent me to photograph McCauley. Teensma also launched *Disney Magazine* and made me his chief photographer. (My first assignment for *Disney Magazine* was to photograph the producer of *The Lion King*, *Beauty and the Beast*, and *The Hunchback of Notre Dame*, Don Hahn, who would later make *Hand Held*, a documentary about our relief foundation and me.) My career as a magazine photographer finally got off the ground, and I became established as a freelance photographer.

Cluj-Napoca is the largest city in Transylvania, with a population of nearly 400,000. An ancient outpost of the Roman Empire, it is set in a river valley surrounded by hills where medieval castles loom large against mountains and sky. The city is rich in churches, museums, and universities—it has the highest student population of all Romanian cities. Babes-Bolyai University, the largest in the country, is famous for its botanical garden.

After spending the night in a Cluj hotel, we rose early for our appointment at one of the hospitals near the city center. We parked our vehicles next to a beautiful Gothic church in the downtown area, St. Michael's, named after the Archangel Michael, the city's patron saint. Evidently, word of our arrival had preceded us. When we disembarked, the doctor in our group was besieged by scores of people, most of them medical students and patients seeking medical advice, treatment, and drugs. For us, it was the first intimation of trouble in the country's health care system.

But the hospital administrators we met with that day firmly denied a crisis of any kind, and specifically denied any occurrence of pediatric AIDS. The *New York Times* had reported such an outbreak early in January of 1990. That had been the breaking news that caused Bob McCauley to marshal a group, including me, to travel to Romania to investigate.

When we were given a tour of the maternity ward in the Cluj hospital, I had my first taste of the inherent incivility of health care under communism. Boasting about the healthy condition of the newborn infants under his care, the doctor showing us around approached one of the young mothers in her bed and unceremoniously pulled her jacket down. (It was so cold in the hospital that most patients were bundled in coats or extra blankets.) Then, to the shock of his American visitors, the doctor exposed the woman's breasts and began rubbing them. Through an interpreter, he explained that the newborn babies were all healthy "because of the big breasts of the mothers." He continued to rub the woman, essentially treating her as though she were some pet cow. The new mother, though clearly terrified, said nothing. I realized with a sinking sensation the contempt with which medical authorities here regarded ordinary people. There was an arrogance in this particular doctor's behavior that was deeply disturbing.

It was a harbinger of things to come.

(FOLLOWING SPREAD) MORNING SMOG, SIBIU, 1990

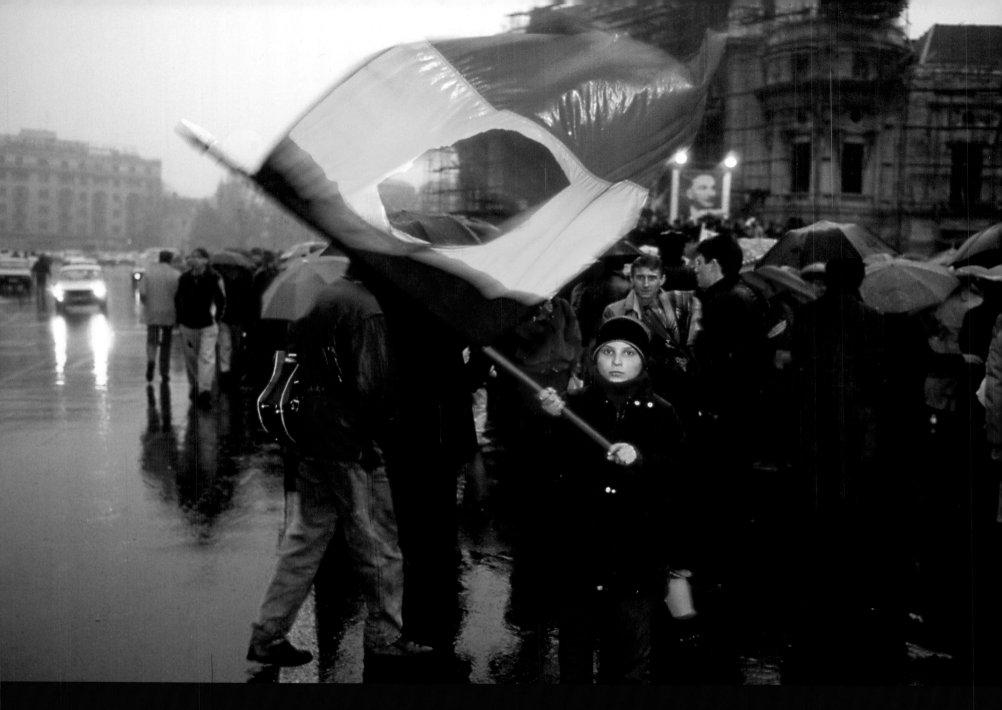

ROMANIAN FLAG WITH COMMUNIST HAMMER AND SICKLE CUT OUT, BUCHAREST, 1990

2. Regime from Hell

WE LEFT CLUJ in the morning, destination Bucharest. Traveling by car over narrow, often badly rutted roads, the trip to the nation's capital would take the whole day, and a good portion of the next. For part of the way, we negotiated precarious mountain passes with spectacular views we were unable to fully appreciate, given how likely it seemed that a single motoring miscue would send us hurtling into a yawning chasm of rocks and trees.

We stayed overnight in the Transylvanian town of Sibiu, at the geographical center of Romania and as such an important trading nexus for centuries. At the moment, it was more celebrated for its role in the violent protests of the previous December that had led to Nicolae Ceauşescu's overthrow. Sibiu had suffered the most casualties, second only to Bucharest. The official death toll for the whole of the revolution was 1,104, with more than 3,000 wounded; an estimated 99 people were killed in Sibiu. These casualties were still recent at the time of our visit, and the tension among the populace was palpable.

With this as background, the hotel clerk insisted on assigning us rooms on the upper stories of his establishment, to make it less likely that we would be targeted by some unidentified assailant. (The hotel had been strafed by bullets during the uprising in December.) He even suggested we sleep on the floor instead of in bed, to maintain a lower profile. After our long, bumpy ride, I chose the comfort of a bed that night, but I was not totally immune to anxiety. I remember making it a point not to walk by the window in my room while lights were on.

Although we had made no arrangements to do so beforehand, we hoped to visit a state-run orphanage while we were in Sibiu. If AIDS had infected young Romanian children, the disease was as likely to show up in the country's crowded orphanages as in the pediatric wings of its hospitals and clinics.

In the morning, we went to the town square in hopes of finding someone who could direct us to the orphanage. A Gypsy woman with a blind child in tow was begging in the square. It was clear to me that city dwellers passing by this

woman felt nothing but disdain for the beggar. It was the first time I became aware of the lowly status of the Gypsies, or Roma people, in the country. In the coming years I would encounter the Roma time and again in coping with the problem of abandoned children.

When we finally learned the location of the orphanage in Sibiu, in a nearby residential area, we went there directly, only to find a burned-out building. A woman who lived nearby approached me while we pondered our next move. She told me the military had removed the orphans and torched the place after hearing reports of sexual abuse of the orphans by members of the local Securitate. She seemed to think that Ceauşescu's youngest son, Nicu, who was a Party official in the area at the time, was mixed up in the abuses. I was never able to confirm or disprove her various allegations.

What is a certainty is that there were hundreds of orphanages in Romania at the time of my first visit there, more than twenty in Bucharest alone. No absolutely reliable figure has ever been substantiated, but it is believed there were from 160,000 to 400,000 abandoned young in the country by the time the Ceauşescu regime collapsed.

How this surplus of unwanted infants and children came about is a story of social engineering at its most diabolical. In 1966, Ceauşescu announced a plan to increase Romania's population with a decree that in effect made pregnancy a state policy. "The fetus is the property of the entire society," he declared. "Anyone who avoids having children is a deserter who abandons the laws of national continuity."

Under the "overplanned parenthood" plan, as *Newsweek* dubbed it, sex education and birth control were outlawed. Abortion became a criminal offense for both women and doctors. Women of child-bearing age were each required to give birth to five children. Women under the age of forty-five were periodically taken from their workplaces to clinics where they were examined for signs of pregnancy, often in the presence of government agents known colloquially as the "menstrual police." Women who did not have children, even if they could not physically get pregnant, paid a "celibacy tax" of up to 10 percent of their monthly wages.

Under this bizarre pro-life scheme, Romania's birth rate nearly doubled. But most families were forced to reproduce beyond their capacity to care for the children. The average wage of the working class was less than $25 a month. At the time, Romania had the lowest standard of living and one of the highest rates of unemployment in Europe. Romania, alone among the world's nations (save another despotic regime, Albania), boasted no foreign debt, reflecting Ceauşescu's determination to be obligated to no power outside Romania. But the Romanian people paid a terrible price for their leader's perverse thrift.

Poor nutrition and inadequate prenatal care endangered pregnant women and their babies. Ceauşescu's minister of health expected citizens to live on a diet of 1,100 calories a day.

With food and medicine in short supply, disease became rampant even as the Romanian caregiving system foundered. (The regime had shut down schools of nursing, psychology, and social services in favor of training in such hard sciences as chemistry and physics, so there was no such thing as a safety net for families who had fallen into poverty and ill health.)

A report issued by UNICEF in 2005 noted the effects of Ceauşescu's scheme: "The communist government had developed a system of values for 25 years that undermined family ties, encouraged dependence on the state, weakened

the capacity of families to care for their children, and generally promoted the neglect by parents of their parental responsibilities and, sometimes, even of their own lives."

Unable to take care of their children, parents dropped off unwanted youngsters at the gates of the nearest orphanage or in the maternity wards of hospitals. A mentality developed among the people: They were children created by Ceauşescu's insane policies, so let Ceauşescu take care of them. The government established a nationwide chain of orphanages as a release valve for the social pressures it had created; soon these institutions became holding pens for the poor and destitute.

When we finally arrived in Bucharest from Sibiu late in the afternoon of February 19, we found not "the Paris of eastern Europe," as Bucharest had once been known, but a city broken by decades of misrule, where heating, gas, and electricity blackouts were part of daily existence. We could barely discern the outlines of the streets and buildings, so thick was the smog being pumped into the air by industrial pollutants from the hundreds of factories that Nicolae Ceauşescu, the "Supreme Leader," had ordered built to transform Romania's economy.

A peasant himself, Ceauşescu turned to the Romanian countryside for the workers he needed to man his new factories. His goal: to create a "homogenous Socialist population out of the traditionally peasant-based Romanian people." Depopulating village after village, he transported peasants to Bucharest by the tens of thousands, installing them in Soviet-style concrete tenements without kitchens or bathrooms because, as Ceauşescu's chief architect once remarked, "they didn't have toilets in their old homes, why do they need them in the city?" Within a year or two, the halls and stair-

wells of the bleak public housing stank of urine and feces.

Late in the afternoon of our arrival, we checked into the InterContinental, one of several hotels that catered to foreigners. A couple of days later, after I had decided to stay in the city to take more photographs, a young Romanian whom I had hired to be my driver and interpreter refused to enter the hotel. He claimed there were hidden surveillance cameras and microphones everywhere in the building. I thought he was probably overreacting, but as it turned out, the fingerprints of Ceauşescu's Securitate were on everything in Romania. According to one of the dictator's high-placed military aides, Major General Ion Mihai Pacepa, who had defected in 1978, every one of the more than three hundred employees of another downtown hotel, the Athenee Palace, was either an intelligence officer or a recruited agent, from the top manager to the lowliest scrubwoman. Ceauşescu himself once boasted that he employed one security officer for every fifteen Romanian citizens.

Without question it was unsettling to be in Bucharest so soon after the summary execution of the Ceauşescus, especially with the economy on life support and the future leadership of the country up in the air. I was with a small aid group on a single, narrowly-focused humanitarian mission. While we were not being greeted with open arms by our hosts in the Romanian health care community, we didn't think we were regarded as security threats, either. Nevertheless, I allowed myself to entertain mildly paranoid thoughts from time to time as I sat with associates in restaurants or hotel lobbies. Could those ubiquitous ceramic ashtrays and flower vases be listening to us? (The short answer: yes. Invented by the Soviet KGB, embedded microtransmitters were secretly used by all East European security

services in those days for monitoring private conversations in public places.)

In the days that followed, between visits to hospitals and orphanages with the AmeriCares group, I wandered the streets of Bucharest, collecting images and impressions of a dysfunctional nation and a demoralized populace. Everywhere I saw long lines of people waiting outside bakeries for their daily bread ration. I peered into grocery stores, pharmacies, appliance stores, clothing stores—and beheld row after row of empty shelves. With staples such as flour, eggs, butter, and milk hard to find, many people depended on small gardens cultivated in city alleys or out in the country.

Escalators leading to the city's subway system were not running. At one entry, a woman huddled in a cloth coat and scarf stood behind a table with cut flowers for sale on it. Other women—Gypsies, I was told—swept the street with rustic straw brooms. One day I saw a small funeral procession go by, the mourners walking in tight formation behind a wagon carrying an open coffin with the body of a child in it. Another day two young men drove by in a car devoid of doors, with the roof of the car, or some other car, upside down in the back seat.

In the streets, horse-drawn carts mingled with trucks belching dark diesel smoke, crowded buses, motorcycles, bicycles, and quirky little cars of East German, Hungarian, and Romanian origin. One day I talked with a woman who spoke some English. She drove a Dacia, the car model produced by a joint venture of Renault Motors of France and Romania. Actually, she told me she owned several Dacias—one to drive and the others to supply parts when the first car broke down. Later I discovered this was a com-

mon strategy in Romania for keeping an automobile in running condition. (When the Dacia was introduced in the United States in 1986, the normally taciturn Dan Rather did a comic turn in a segment for the *CBS Evening News* titled "Dacia, as in Gotcha," in which he showed all the things that went wrong with the Dacia when someone tried to drive it. The final straw came when the driver could not turn the engine off, even after removing the key, until he had turned the headlights on.)

Remnants of the old city's sophisticated architectural design contrasted sharply with the severe, fiercely featureless totalitarian style of the communist world order. To make room for his presidential palace, a pet project, Ceauşescu had ordered the demolition of the heart of the city, beginning in 1986. Historic churches, monasteries, hospitals, libraries, and other civic buildings had been reduced to rubble. Radio Free Europe, long a thorn in Ceauşescu's side, estimated that some 15,000 venerable dwellings and public monuments had been razed. RFE pronounced the wholesale destruction "a desecration of a country's heritage unparalled in twentieth-century Europe."

I reached the palace by way of a long, grandiose boulevard studded with fountains now empty of water. To me the Casa Poporului—"The People's House"—resembled nothing so much as an oversized insurance company headquarters, monolithic and bland. It is said to be the second largest administrative building in the world, after the Pentagon. It has since been renamed "The Palace of the Parliament," but it still looked like Aetna Life to me.

I returned to Piata Universitati, or University Square, where our hotel was located, opposite buildings of the University of Bucharest. On a wall of one university

building, square patches of mortar covered bullet holes. Nearby, a "Martyrs' Wall," abounding in flowers and handwritten tributes, had been established to honor the victims of shootings by the Securitate on the occasion of Ceaușescu's final speech to a nation he had ruled with such cruelty. "Death to the Devil Ceaușescu" was one message scrawled on the wall.

It seemed incredible, but scarcely six weeks prior to my arrival in Bucharest, the fortunes of the country had played out on another city square not far from where we were staying. On December 21, from the balcony of the central committee building, Nicolae Ceaușescu had begun his address with the usual cant about the glories of "scientific socialism" and Romania's greatness in every sphere of human activity. His remarks and the reactions of the crowd of 100,000 were captured for posterity by Romanian State Television, which had several fixed camera locations up and running for all such propaganda events. Today, thanks to YouTube, you can witness this remarkable piece of political theater, symbolizing, perhaps even more powerfully than the fall of the Berlin Wall, the collapse of communism in Europe.

It should be noted that Elena Ceaușescu, as always, was at the side of her beloved *Conducator*. In recent years, Elena had risen in effect to a position of co-leadership in Romania, with special power and influence in domestic affairs—the tragic forced-pregnancy program was one of her special claims to fame. The daughter of a tenant farmer, Elena had fared poorly in grade school, failing in all her courses except needlework and gymnastics, but after leaving the farm for Bucharest, she met Nicolae among a small circle of Marxists, and the two fell in love. Once in power, Elena made up for her academic failings by awarding herself a Ph.D. in

chemistry, and forcing genuine scientists to author books in her name. Elena was bitten by the political bug in 1973 on a state visit to Argentina, where she became fascinated by the person and persona of Eva Perón. Thereafter she was a constant presence at her husband's policy meetings, developing a style of vulgar verbal abuse that left Ceaușescu's top officials cowering. "The witch is like the bubonic plague," commented one minister. "Everybody hopes the Comrade will outlive her."

Minutes into his speech from the balcony of the central committee, a chant arose from the crowd in Piata Palatului: "TI-MI-SOA-RA, TI-MI-SOA-RA!"

As for all such occasions, busloads of communist sycophants had been brought into the city the night before to provide "spontaneous" support for the Supreme Leader. But this day there were also numerous disaffected intellectuals and students in the crowd. Only days before, military forces, police, and Securitate had fired on anti-Ceaușescu demonstrators in Timisoara, a city in western Romania, near the borders with Yugoslavia and Hungary. It was this violent suppression that the chanters were protesting.

When tear gas grenades exploded in the square, the crowd grew angrier. State Television recorded the stunned expressions on the faces of Nicolae and Elena Ceaușescu as they heard the unprecedented outrage directed at them:

"Down with the murderers!"

"Romania, awake!"

"Ceaușescu, *we* are the people!"

As people began singing long-banned patriotic songs dating from before World War II, Elena was observed going to her bewildered husband's side and speaking with urgency.

"Promise them something," she said. "Talk to them!"

In an absurdist moment worthy of the Romanian-born playwright Eugene Ionesco, Ceauşescu did as he was told. He suddenly announced to the crowd that he was increasing everyone's wages and pensions.

It was too late. The boos and catcalls crescendoed. Ceauşescu staggered backward. Moments later, he and Elena were whisked off the balcony and out of sight.

The next day the couple was flown by helicopter to an army barracks in Tirgoviste. With the army firmly committed to the uprising as it spread throughout Bucharest and other cities, Securitate agents decided not to risk their own necks by attempting to help the aging dictator. A trial lasting less than an hour, as unconvincing as the Stalinist show trials of the 1930s, found the Ceauşescus guilty of various charges, including genocide and stealing from the state. Denying any guilt whatsoever and denying the legitimacy of the court, Nicolae Ceauşescu remained dignified to the end. Elena remained shrill. "I can't believe this," she was heard to remark as she and her husband, their arms bound behind them at the wrists, were led outside. "Is the death penalty still in force in Romania?"

Four soldiers selected for the task placed the Ceauşescus against a wall and promptly emptied about thirty rounds each into the couple with semiautomatic rifles.

It was Christmas Day.

FLOWERS FOR MARTYRS OF THE REVOLUTION,
UNIVERSITY SQUARE, BUCHAREST, 1990

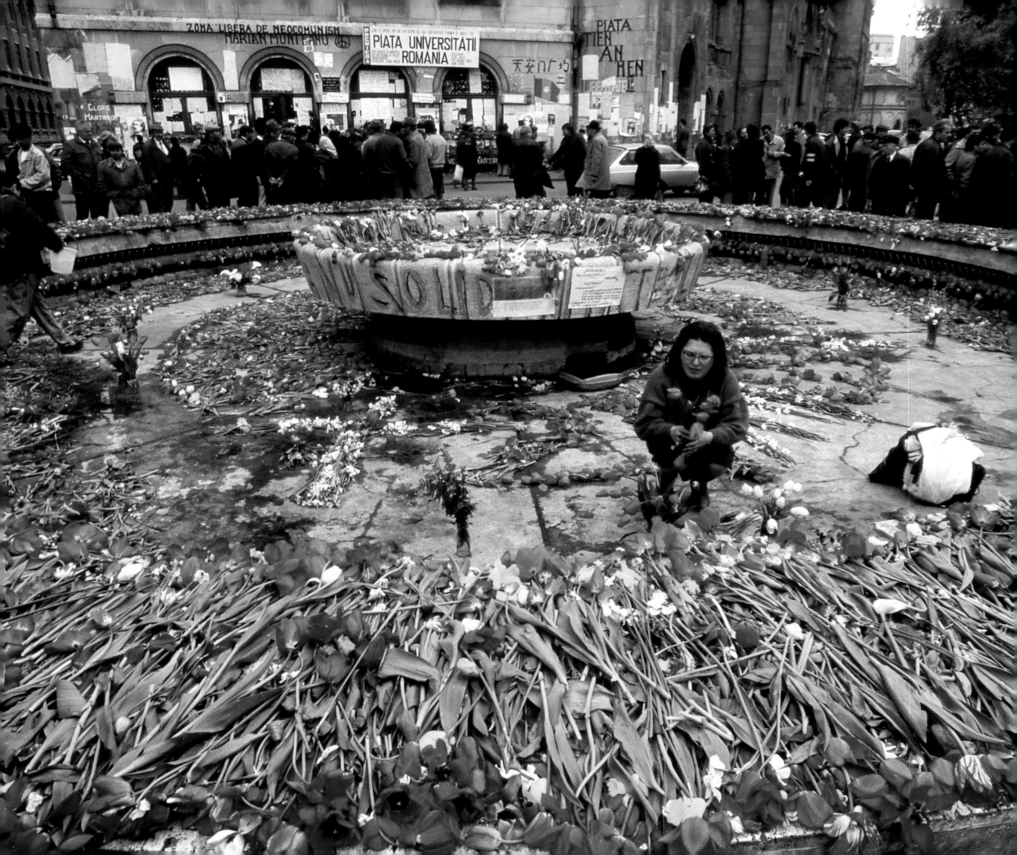

30

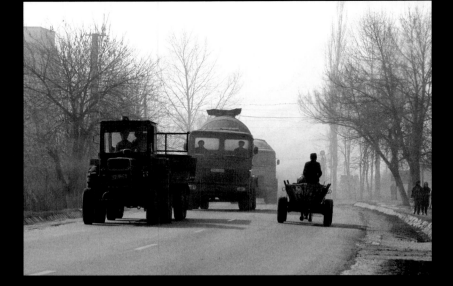

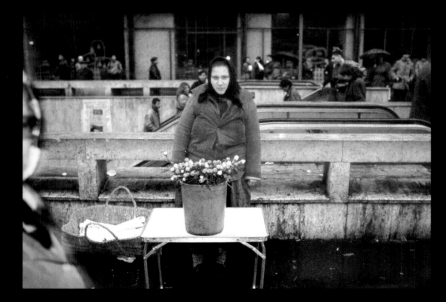

(TOP) MIXED TRAFFIC ON MAJOR HIGHWAY, NEAR OCNA MURES, 1990

(BOTTOM) FLOWER VENDOR AT SUBWAY ENTRANCE, BUCHAREST, 1990

EMPTY SHELVES IN GOVERNMENT STORE, BUCHAREST, 1990

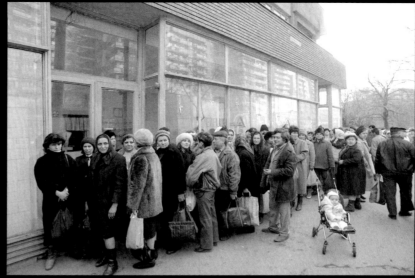

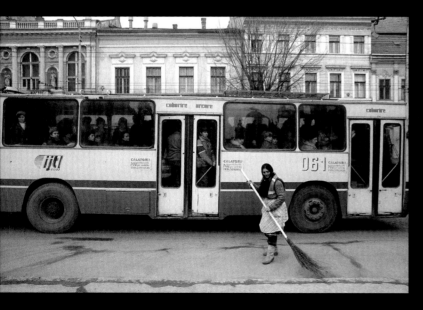

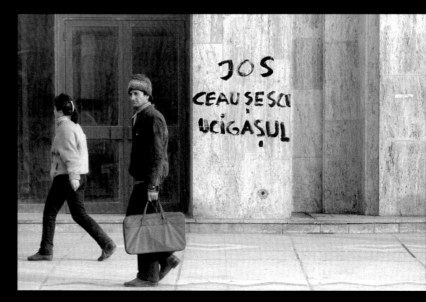

(TOP) JEWISH COUPLE IN THEIR ONE-ROOM APARTMENT,
BUCHAREST, 1990

(TOP) LINING UP FOR MILK, BUCHAREST, 1990

(BOTTOM) "DOWN WITH CEAUŞESCU THE DEVIL," BUCHAREST, 1990

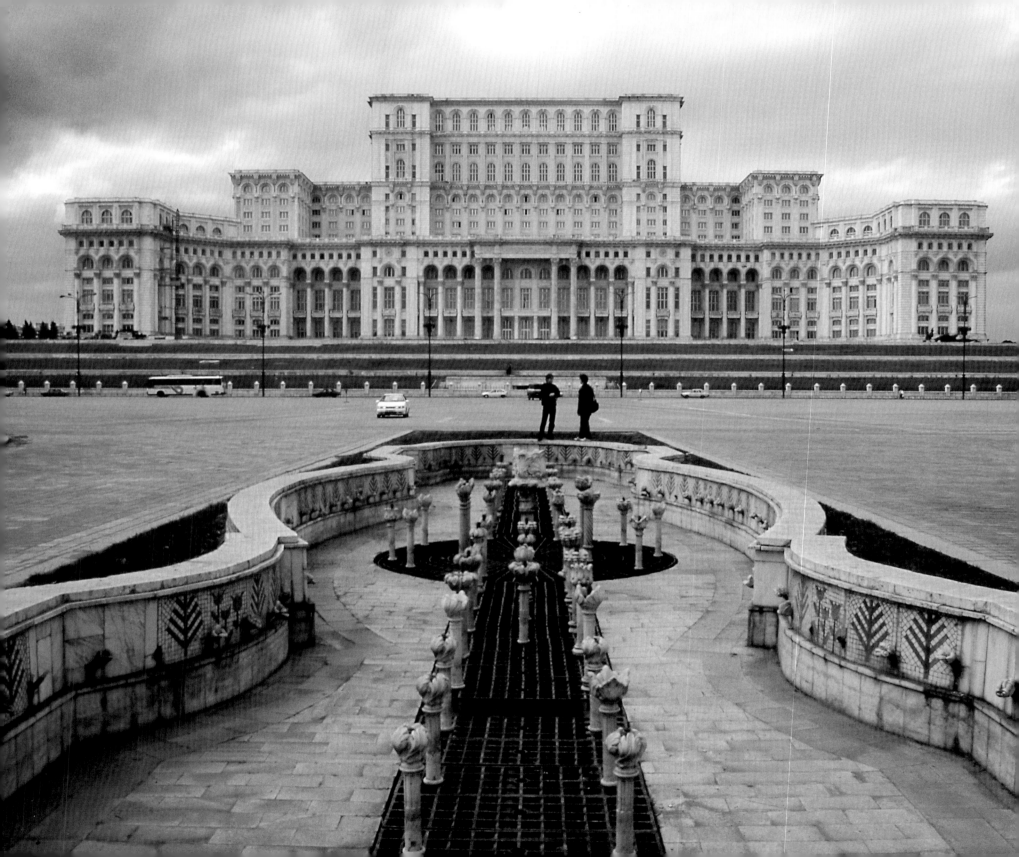

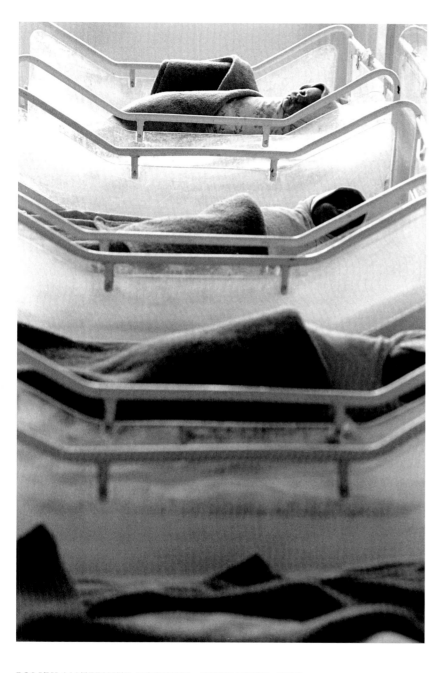

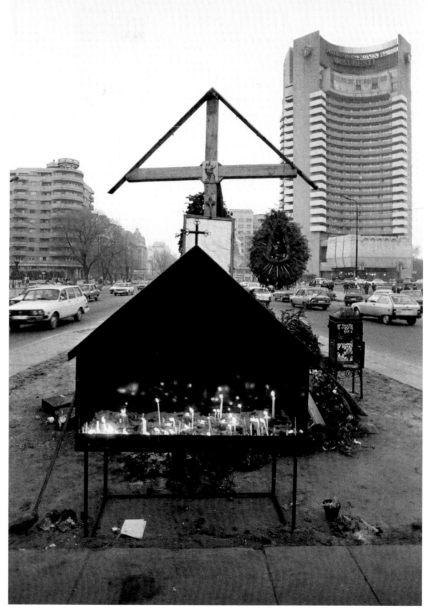

POLIZU MATERNITY HOSPITAL, BUCHAREST, 1990

(OPPOSITE LEFT) CONSTITUTION PLAZA, BUCHAREST, 1990

IMPROVISED MARTYRS' SHRINE, UNIVERSITY SQUARE,
BUCHAREST, 1990

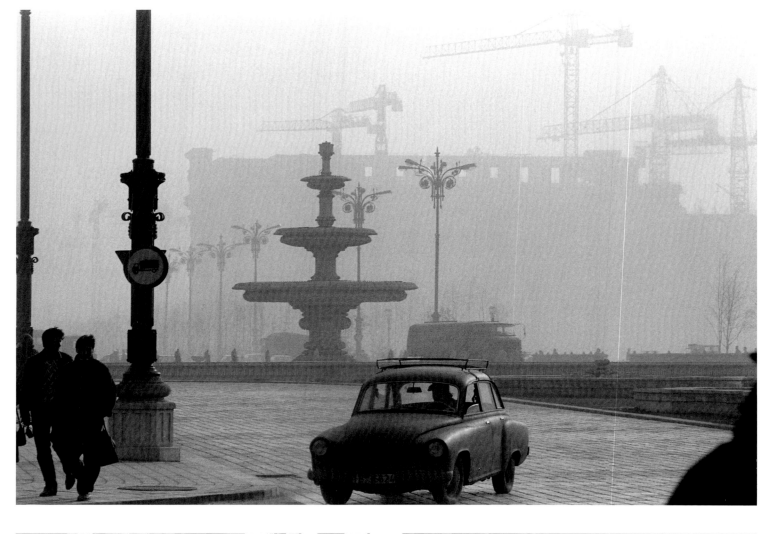

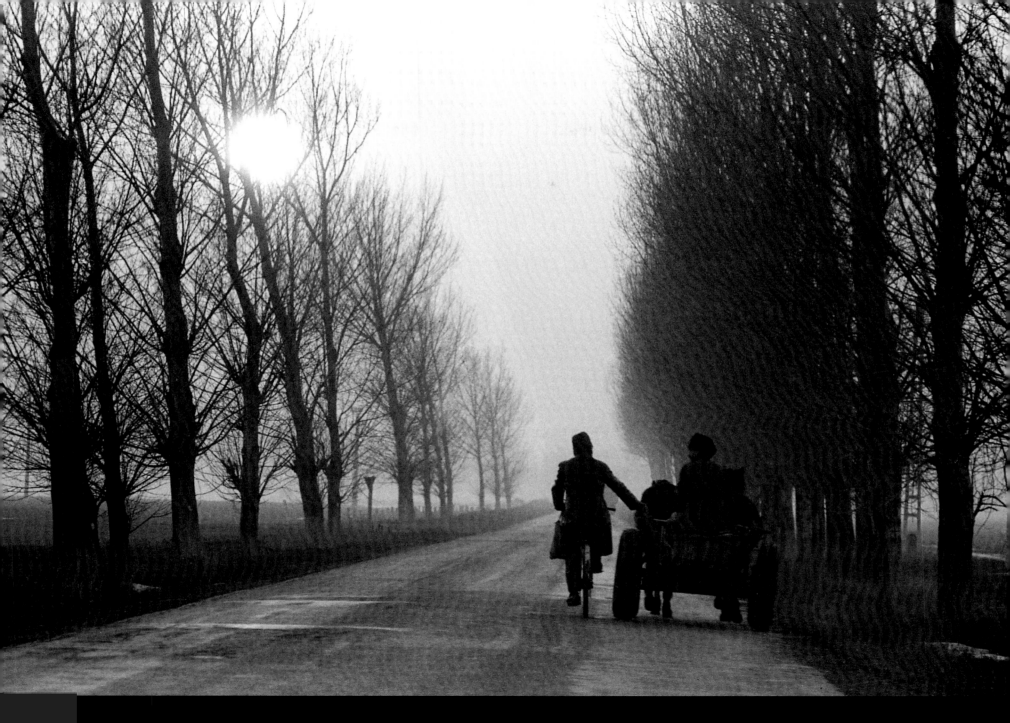

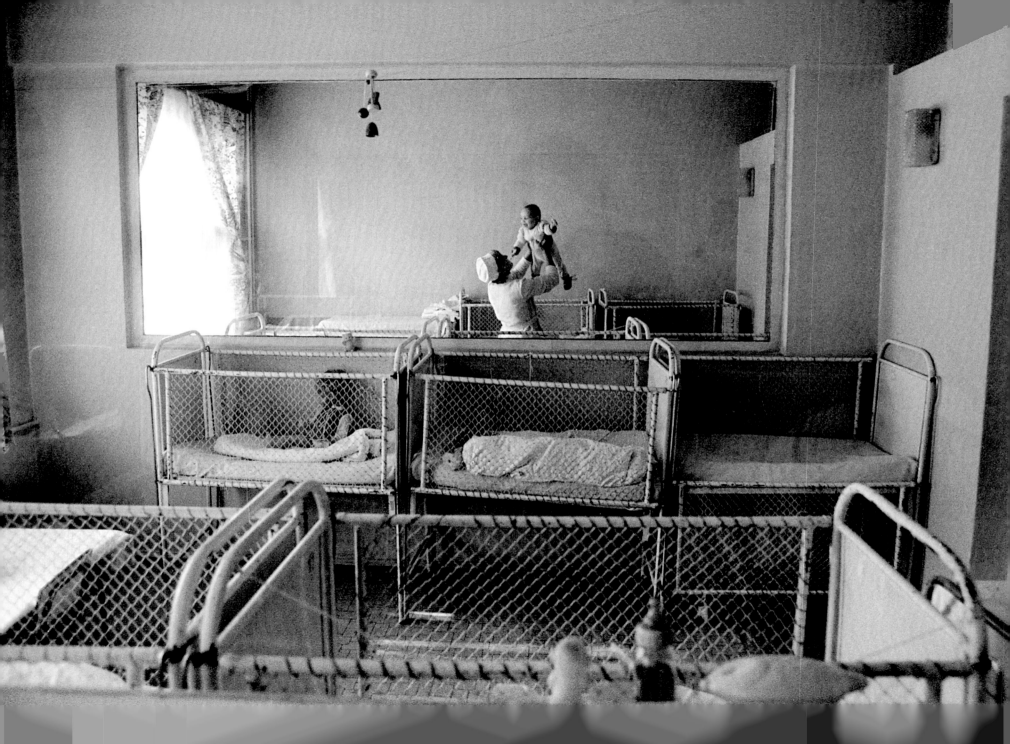

3. Romania's Abandoned Children

ON THE SECOND DAY after our arrival in Bucharest, we piled into our two vehicles early in the morning and headed for Victor Babes Hospital, located in a poor city neighborhood not far from the hotel. The post–World War II buildings that made up the hospital compound were blocky and featureless. The hospital, specializing in infectious diseases in children, is named after a Romanian physician and biologist who pioneered the study of rabies, leprosy, diphtheria, and tuberculosis.

Victor Babes was born in 1854 in Vienna, then the capital of the Austrian Empire, to an ethnic Romanian family from the Banat region in the westernmost part of Romania. He studied in Budapest and Vienna, where he received his doctorate in science. Intrigued by the discoveries of Louis Pasteur, he left for Paris and worked in Pasteur's laboratory before settling in Bucharest, where he practiced medicine and taught pathology and bacteriology until his death in 1926.

Babes is a revered figure in scientific circles in Romania, having written the world's first treatise on microbiology and having discovered more than fifty new germs in his career. But he was not just a lab rat. A man of great compassion, he took pains to place science in the service of people, studying the social roots of communicable diseases, for example, and fostering preventive medicine, as in his work to ensure the quality of water supplies in the country's far-flung towns and villages. (The Babes-Boylai University in Cluj-Napoca and the University of Medicine and Pharmacy "Victor Babes" in Timisoara also bear his name.)

I go on at such length about Victor Babes because, as it turned out, if ever Romania stood in need of a good doctor, it was now.

Upon arriving at the hospital, we were greeted by the director, who was also the head of the University of Bucharest Medical School. He took us into his office and introduced us to staff members. Someone came in and served coffee to the group. Most of the conversation that ensued was in French—not my forte, but I did understand the gist of the exchange when Dr. Bill Griffo, an oncologist from New York's Cornell Medical Center who had volunteered to accompany the AmeriCares team, mentioned to the director that there had been published reports in Europe

and America about an AIDS epidemic in Romania.

"Those are just rumors, fortunately," the director replied through an interpreter, echoing the official line we had already heard in Cluj. "There is no such disease in our country."

After a while, I excused myself. I was restless and not a little frustrated. Meetings in offices and conference rooms are not the stuff of great photography. Doors seemed to be politely closing on us everywhere we went.

I went outside and wandered around the interior court-yards of the hospital. From the third floor of one building, small children looked down at me through a barred win-dow. I don't place much stock in omens, but the penetrating gazes on the children's faces seemed to hold some essential truth about their condition. They didn't look sick from a distance, but they looked dislocated—lost.

Hospital workers were burning used bandages and other medical trash in an open container in the middle of another courtyard. I discreetly photographed them as they went about their business, sending clouds of noxious smoke into the air. I was no authority on such things, but I thought it was probably not a good idea to be burning potentially haz-ardous material on hospital grounds.

I came to a small building that looked older than any of the others, with more ornamentation and style. A man in a soiled white lab coat came out and stood in the doorway, assessing me. He wore oversized glasses and a Russian-style hat. He sported a moustache. I guessed he was in his thirties.

He was Augustin Petrescu, the hospital mortician. Years before, while taking courses in foreign relations at the uni-versity with an eye toward becoming a diplomat, he was present when an apparatchik appeared in the classroom and announced that Romania needed morticians. Therefore half the students in the class, said the official, would drop their existing career goals and devote themselves to becoming morticians. And so Augustin found himself working as a mortician against his will.

"We have been waiting for you," he said, directing his gaze at my camera bag. "Do you speak English?" he inquired anxiously. "Come in before they see you. I want you to take pictures and show the horror of what we have been living with."

I followed Augustin inside the building, which turned out to be the hospital morgue where he worked. The room on the first floor looked like a laboratory of some kind, with several metal examining tables, perhaps used in the conduct of autopsies.

He led me downstairs to a dank basement room with peeling paint and a single 40-watt bulb hanging from the ceiling. The moment we pushed through its heavy metal door, I was overcome by the sulphurous stench of rotting flesh and formaldehyde.

"Now see this," he said, pointing to a line of stretchers along one wall. At first, I couldn't make out what was piled on the stretchers in the gloom. Then I realized they were stacked with tiny corpses—five or six babies and young chil-dren piled up like cordwood on each stretcher.

There were at least twenty bodies in the place. Some of the children had been dead for a long time, and their bodies were badly decomposed. Others had died more recently, and their open eyes, huge and haunting, seemed filled with accusation.

I thought I might throw up, and I fought to control my hyperventilating. (I'd been to Lamaze classes with Joan in preparation for the birth of our first child, and the breath

control methods I learned there proved to be helpful in this place of death and decay.) What saved me in the end was taking pictures to document the human calamity before me. The attention to detail required to shoot in such poorly lit conditions—setting the correct f-stops and shutter speeds on my predigital camera—kept my emotions in check.

"I and my assistants," Antonin told me, "we feel we will all die of AIDS now, anyhow, and we can't be in collusion with a government that is this criminal."

He explained that, prior to Ceauşescu's downfall, agents of the Supreme Leader's Securitate had come by at night to collect bodies from the morgue and take them to some secret location for mass burial. Now, with the government in disarray, that practice had stopped, and so the bodies piled up.

"But how do you know it is AIDS that is killing these children?" I asked at one point.

Antonin explained that he had begun obtaining blood samples from the victims months ago, before the collapse of the regime. He had taken the samples for testing to a doctor, who worked in a veterinary research clinic adjacent to Victor Babes. (Coincidentally, Dr. Babes had also been highly influential in the field of veterinary science in his day, and was the first to introduce the rabies vaccine into Romania.)

Augustin's colleague had studied retroviruses, which include AIDS, HIV, and hepatitis B, in the United States, as it happened. His testing led him to conclude that the blood from the dead children contained a retrovirus that was most likely AIDS. Augustin and his helpers had used manual pipettes to obtain their samples, so their infection with the AIDS virus was by no means certain but within the realm of possibility. Although not entirely sure how the AIDS virus

spreads, Augustin was decidedly gloomy about the prospects for his own health. At the same time, I found him amazingly courageous in his determination to expose the ravages caused by the disease among Romania's young.

After showing me the bodies in the morgue, Augustin offered to take me to the pavilion, or ward, where the victims had come from. We walked to a building at the far end of the compound and took the stairs to the third floor. In the first room we entered I was struck with the same shock and revulsion I had felt in the morgue, for here were the living dead. Infants and young children sat or lay on plastic-covered mattresses in rusty cribs lined up against a paint-chipped gray wall. They appeared in various stages of illness, all malnourished and neglected. They wore rags for diapers. Everywhere was the putrid odor of feces, rotten eggs, and ammonia.

"I've got to get my people here," I told Augustin. I raced down the stairs and out the door. There was the hospital director leading the team in my direction. I signaled for them to follow me. Later I realized that, for his own reasons, the director chose not to join the tour.

The team spent about an hour and a half going from room to room in the pavilion, which held a total of 86 children. One of the most unnerving things about the experience was the silence of the youngsters. There were none of the sounds that might be heard in a typical children's hospital—no crying, laughing, screaming, whining, moaning. Except for one child who was experiencing seizures, there was no movement among the children. It was as if these sad little beings were already gone from the world.

We were all so caught up in their plight and our inability to do anything about it that we dared not look at each other.

We were tearing up and inarticulate. Once again I turned to my camera to block out painful emotions and concentrate on capturing the children on film. The volunteers from AmeriCares found the same temporary relief by busying themselves with their video cameras.

His face ashen, Dr. Bill Griffo went from crib to crib, examining children at random. One emaciated boy, perhaps three or four years old, lay naked on his back, staring up at us almost as if he were in a trance. Bill pointed to a sarcoma on the boy's thigh. "This is full-blown AIDS," he said to no one in particular, "not AIDS symptomatic." He consulted with the woman doctor and the head nurse on duty in the ward. "Full-blown AIDS," he repeated.

"As an oncologist," he told me later, "I'm always confronted with the limitations and failures of medicine. But I was not prepared emotionally or professionally for Romania's AIDS babies."

We went back to the hotel, wondering what to do next. We were drained, emotionally and physically, from the hospital visit, but we felt an obligation to learn more about what was clearly a public health crisis that had not yet gone public. We'd learned from hospital staffers that most of the sick children came from orphanages, so we decided we should visit at least one of them as part of our fact-finding trip. The oldest of the men we were using as a guide, a Romanian-born Hungarian, located an orphanage that was close by our hotel. So the team climbed back into the Land Rover and van.

Orphanage No. 4 was one of about twenty within Bucharest city limits. It was designated a *Leagone*, for children of both sexes. Older orphans lived in institutions separated by sex. There were more than 150 kids in Orphanage No. 4.

Rooms were filled with metal cribs but devoid of play materials, although I noticed a broken-down seesaw in an otherwise vacant courtyard. There were cracks in the walls of the building from an earthquake that had hit the area years before.

A cursory tour of the facility revealed no obvious presence of infectious disease, although as Bill pointed out, the kids were hardly in the pink of health. If any of the children tested positive for the HIV virus, for instance, the orphanages could become pipelines to death.

After a heart-wrenching day, Bill and I looked forward to a drink together in the hotel bar. We called it the *Star Wars* bar because it reminded us of the bar in the George Lucas movie, which catered to weirdo aliens from all over the universe. The cast of characters at the InterContinental included businessmen from the West, smugglers, black marketeers, prostitutes, cigarette vendors, money changers, and guys in black leather jackets who may or may not have been agents from the Securitate.

As we unwound, Bill expressed his concern that we might be in the middle of a pediatric AIDS epidemic, brought on in part by a tainted blood supply and the outdated practice of giving blood transfusions to underweight or developmentally impaired newborns, often with used needles. (Nurses were issued two needles and two syringes per year, which they reused constantly.) Bill had been quizzing Romanian doctors and nurses about the problem ever since arriving in-country.

The practice of microtransmission originated in France in the 1930s as a way of getting vital trace elements from healthy human blood into those who were sick. The blood was administered via the umbilical cord in newborns and intravenously in infants. Some doctors experimented with

the method in the same time period in the United States, without ever obtaining proven benefits.

How had Romania's blood supply become tainted? A possible scenario developed as new information came to light following the collapse of the Ceaușescu regime. Initially, AIDS came into the country through sailors in the Romanian navy, who became infected with the disease after contact with prostitutes in foreign ports (Uganda, which experienced a devastating AIDS epidemic, had been one of Romania's biggest trading partners.) Foreign students in Romania, many of whom came from Africa, also may have been carriers. Sailors and students were required to donate two pints of blood per year. A single pint of contaminated blood could infect dozens of infants because the volume of each inoculation was so small.

Statistics tend to support this theory. In the Black Sea port city of Constanta, in southern Romania, the virus was discovered in 308 of 710 babies tested. The virus traveled from the seacoast inland to the capital, which had the second-highest occurrence. Moving north and west from Bucharest into the mountains, the rate of infection fell off sharply.

Romania's "AIDS babies" were only the tip of the iceberg, it turned out. Many other children would be diagnosed with hepatitis B and C, tuberculosis, and meningitis. Institutionalization had left most of the orphans in poor physical health. Significant numbers were malnourished and had nutritional, growth, and developmental issues. In addition, behavioral problems such as temper tantrums, rocking, sleep disorders, and attachment disorders were present.

Hospital conditions in general were abysmal. Antibiotics that could be taken orally were unavailable. There was virtually no anesthesia—women in labor were strapped to tables when the time came for delivery. There was no heat; doctors delivering babies would warm their hands by plunging them into the discarded placenta. The ratio of caregivers to infants in most pediatric wards: 1 to 20.

Back at the *Star Wars* bar, Bill and I wondered about the state of health of the prostitutes of Bucharest. No problem: two pretty ones were sitting at the bar. We approached them and offered to pay each their "service fee" of $20 in return for obtaining a small sample of their blood. At first they were more than a little taken aback by the bizarre request, but they finally agreed. After all, it would probably be the easiest $20 they earned that night.

We were on our way to Bill's room to extract the blood with hygienically clean needles when we were accosted in the hall by the ladies' representative—their pimp. After a long, somewhat heated conversation in several broken languages, he too relented. He scratched his head and left us to our business.

I'd forgotten all about our *Star Wars* bar adventure until a year later, when Bill and I participated in a medical conference in Prague in what was then Czechoslovakia. I asked him if he'd ever run the blood tests on "the girls."

"Oh yeah," he said with a grin. "Negative."

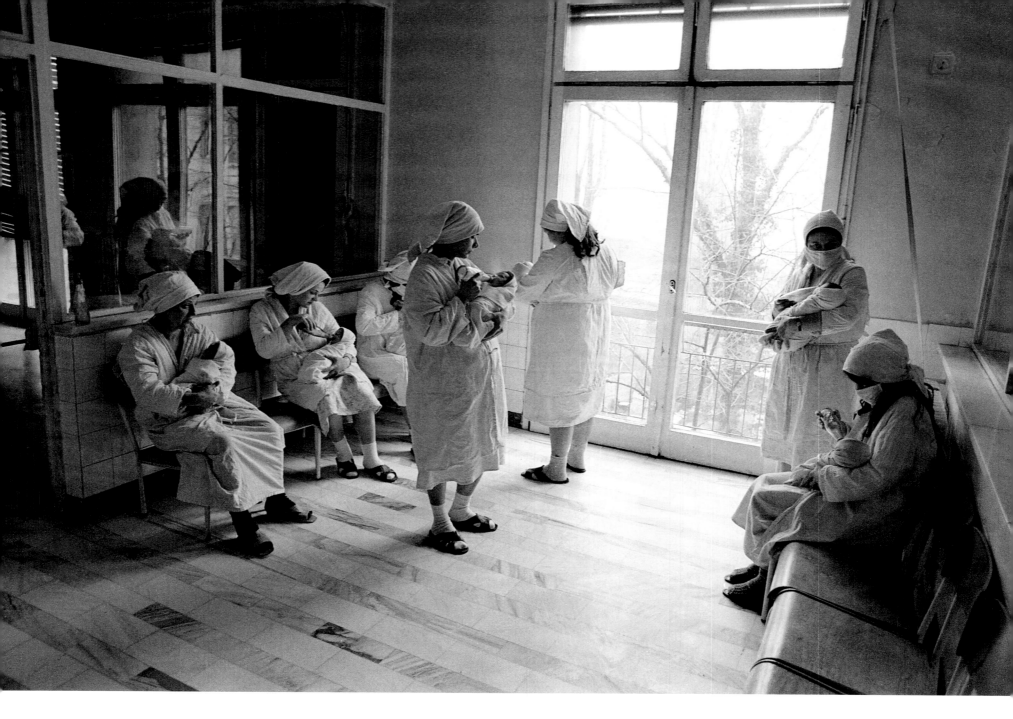

POLIZU MATERNITY HOSPITAL, BUCHAREST, 1990

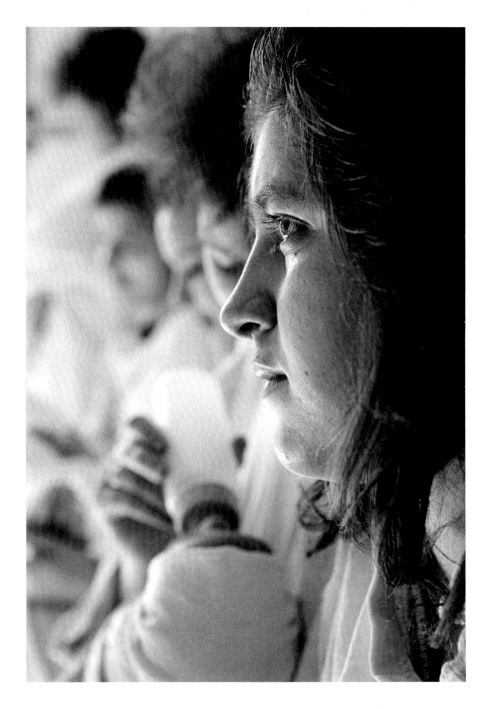

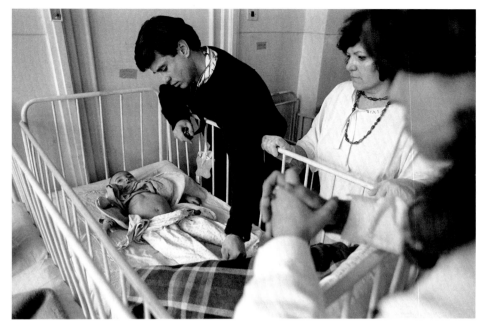

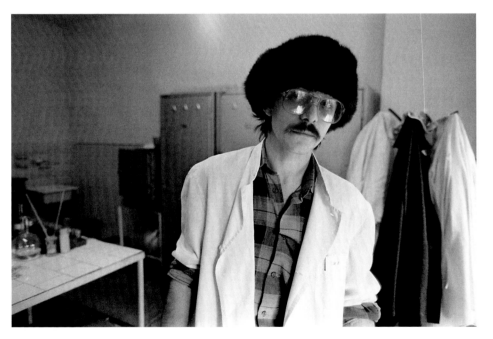

YOUNG MOTHER, POLIZU MATERNITY HOSPITAL, BUCHAREST, 1990

(TOP) DR. WILLIAM GRIFFO, PEDIATRIC AIDS WARD,
VICTOR BABES HOSPITAL, BUCHAREST, 1990

(BOTTOM) AUGUSTIN PETRESCU, MORTICIAN,
VICTOR BABES HOSPITAL, BUCHAREST, 1990

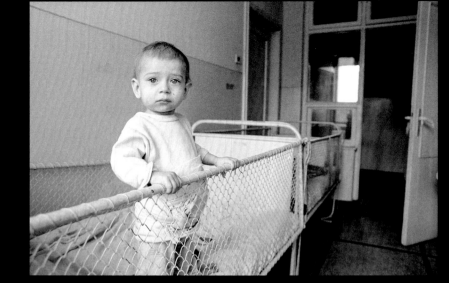
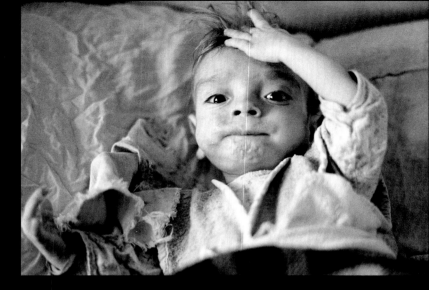
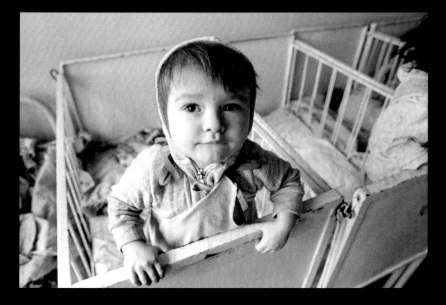
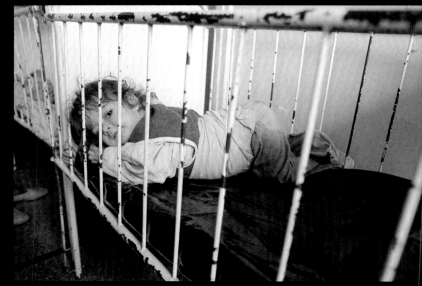

(ALL) PEDIATRIC AIDS WARD, VICTOR BABES HOSPITAL, 1990

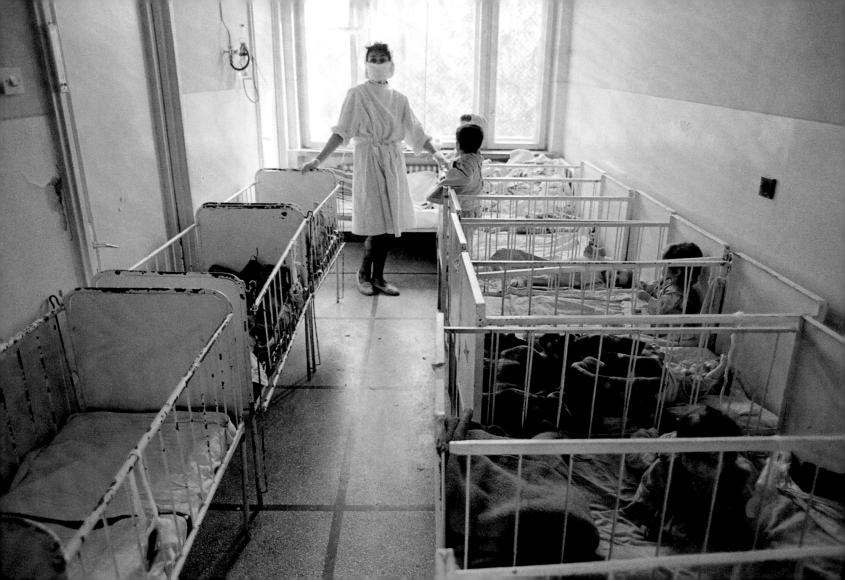

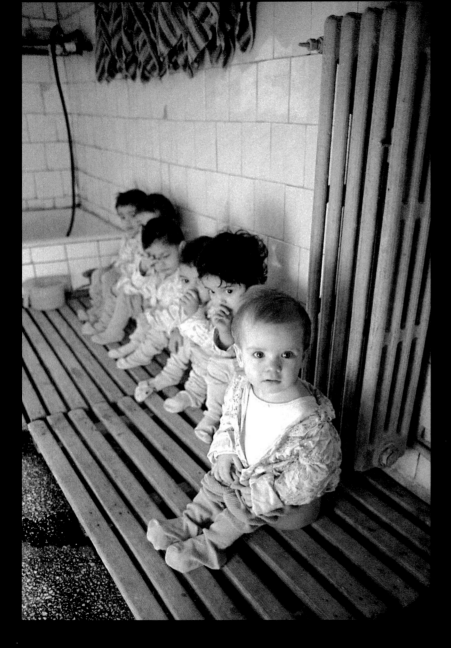

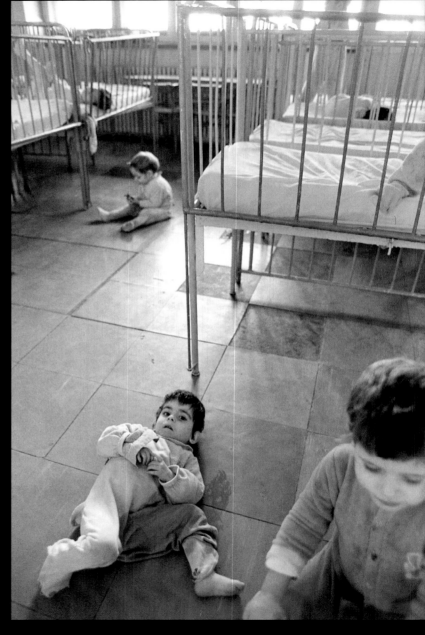

ORPHANAGE NO. 4, BUCHAREST, 1990

ORPHANAGE, CRAIOVA, 1993

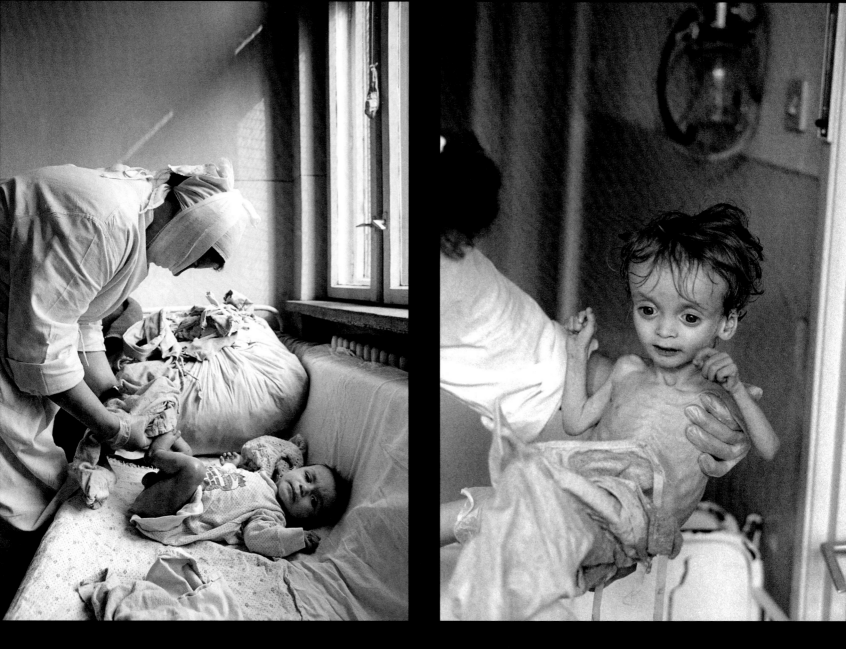

PEDIATRIC AIDS WARD, VICTOR BABES HOSPITAL, 1990

PEDIATRIC AIDS WARD, VICTOR BABES HOSPITAL, 1990

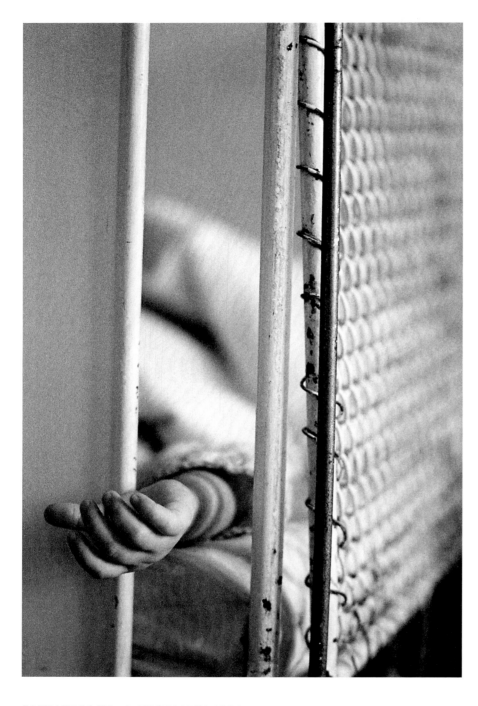

ORPHANAGE NO. 4, BUCHAREST, 1990

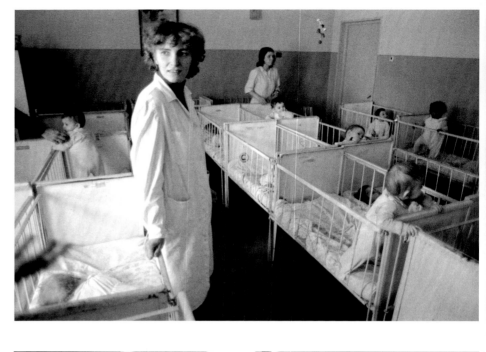

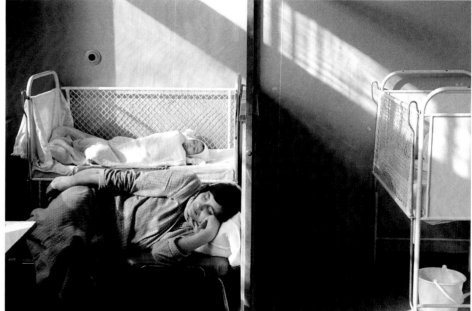

(TOP) ORPHANAGE NO. 4, BUCHAREST, 1990

(BOTTOM) MOTHER AND CHILD, DR. ALFRED RUSESCU HOSPITAL, BUCHAREST, 1992

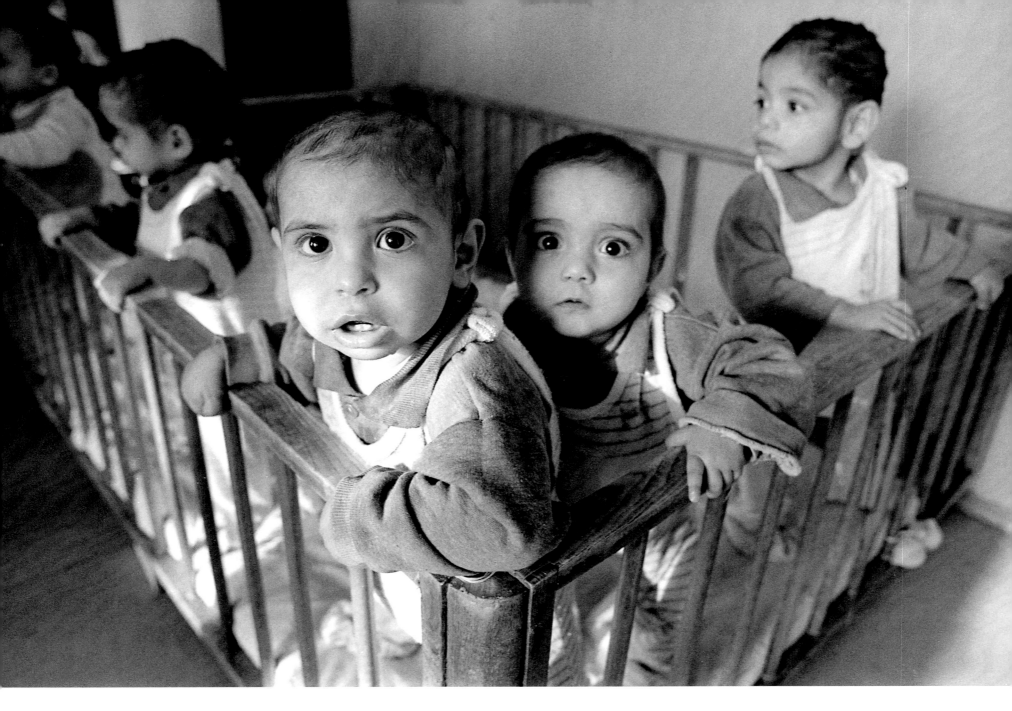

TODLERS WITH HEAD LICE, ORPHANAGE NO. 4, BUCHAREST, 1990

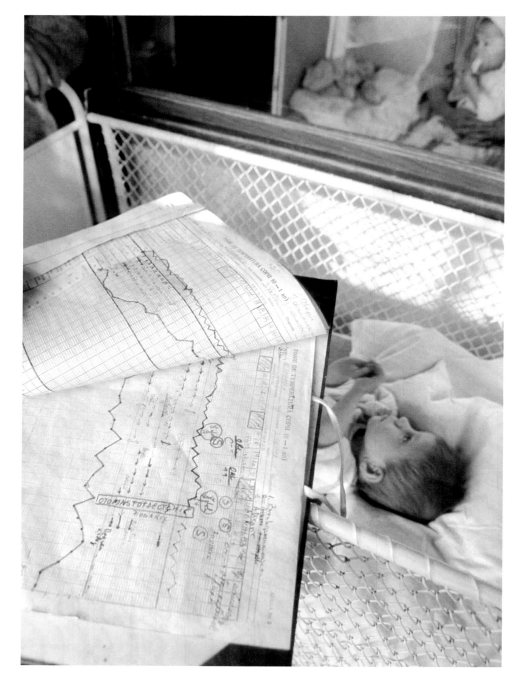

(TOP) INFANT WITH MEDICAL CHART,
DR. ALFRED RUSESCU HOSPITAL,
BUCHAREST, 1992

(OPPOSITE RIGHT) GIRL FROM ROMA
VILLAGE NEAR BUZAU, 1991

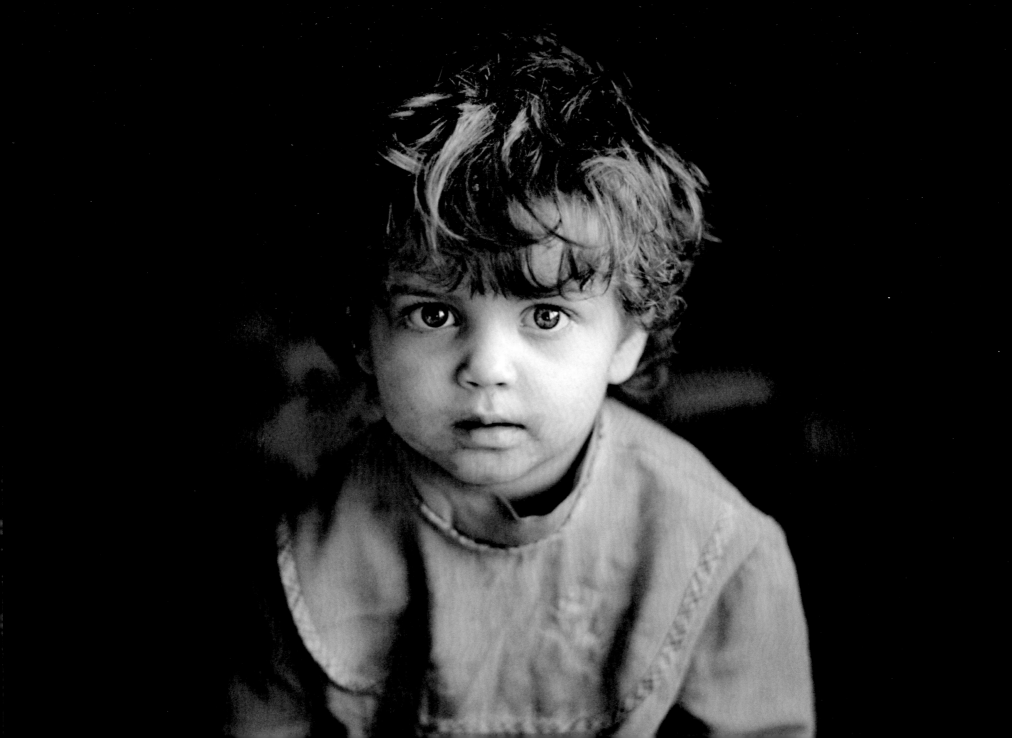

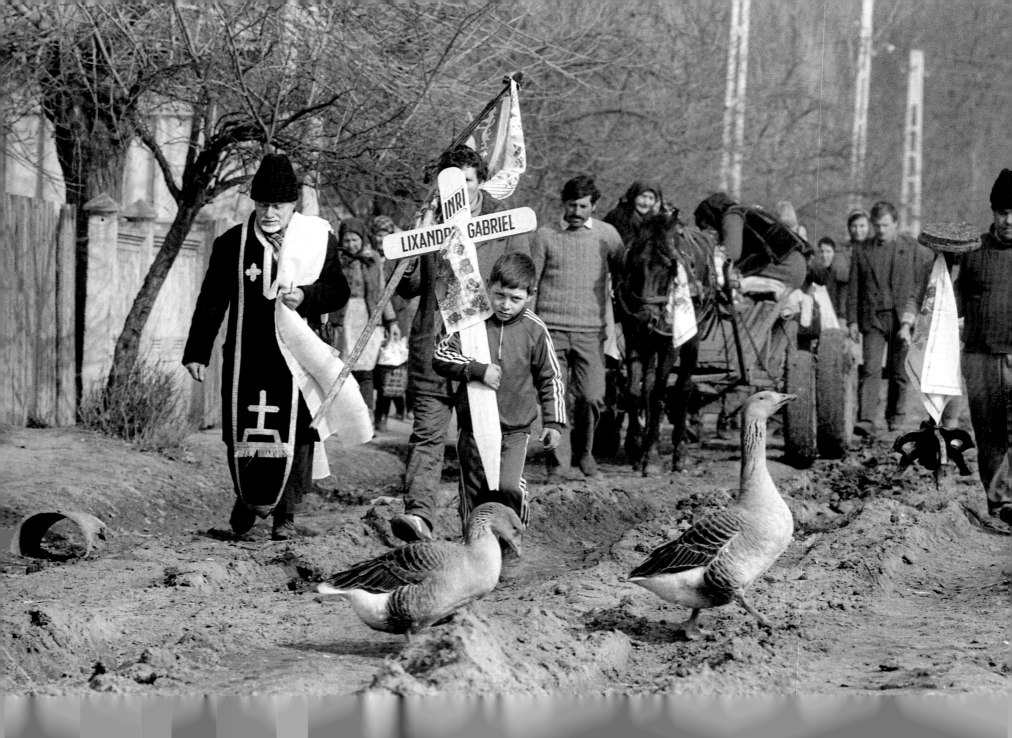

4. Requiem for Gabriel

THE DEVIL IN ROMANIA leads a strenuous and tireless life," the photojournalist E. O. Hoppe once observed. That thought came to mind the day I attended the funeral and burial of a boy named Gabriel Lixandrus, dead from AIDS at the age of eighteen months.

Grief and fear engulfed the village where the ceremonies took place, to such an extent that I realized for the first time the full human cost of the health catastrophe in the country.

The day before I had said goodbye to Dr. Bill Griffo and the AmeriCares team as they headed for the airport. On their way back to the States they would lay over in Paris to give an interview on French television on the subject of the Romanian AIDS crisis, providing videotaped evidence of the scores of sick children in Bucharest. It would mark the beginning of worldwide media reporting on a problem that had been hidden for years behind the Iron Curtain.

I had decided to extend my stay in Romania. I wanted to spend more time photographing Bucharest, the old city as well as the city reshaped by the communist regime, and I wanted to capture some of the faces and figures of ordinary city dwellers. Romanians are Latin by descent, not Slavic, and their language is at the core similar to Italian.

The Russian proverb "Rooster today, feather duster tomorrow" more or less captures the fatalistic Slavic view of life. There is more joie de vivre in the Romanian makeup. A history of endless war and occupation has not snuffed out this spirit entirely. Even in hard times people will find an excuse for breaking out a bottle of the strong plum brandy called *tsuica*. Anyway, I hoped to find some signs of normality amid the political and economic chaos of daily life in the country.

But I did not think my job as photojournalist was done, either. I wanted to bear witness to the effects of the AIDS epidemic outside the confines of the medical system. What, I wondered, was the impact of AIDS on individual families?

I decided to begin my quest with another visit to Augustin Petrescu, the mortician. I had located a local youth who spoke English and was willing to work for me as a translator (as long as I did not ask him to set foot in what he believed to be the spy-infested InterContinental). That morning of my first day on my own, we drove to Victor

Babes Hospital. When I got out of the car, I could not help but notice an incongruous sight: a man in jeans, sweater, and fur hat standing next to a car with a tiny wooden casket lashed to its roof. I asked my translator to sound out the man and his situation.

Gheorghe Iatan, as it happens, was waiting to take the body of his nephew, Gabriel, home. The body was being dressed for the funeral service and burial, scheduled for the next day, by an attendant in the hospital mortuary. I walked to the building where I had witnessed so much horror already. Greeting me somberly, Augustin led me to the room where the dead boy lay, surrounded by weeping women, all family members. On the same table lay two naked corpses of boys, so thin and emaciated their bones appeared ready to burst through the skin. The juxtaposition of this image of human waste with the infant being lovingly swathed in white linen and lace was almost too startling to take in. And to make matters worse, I recognized one of the boys. The day before, I had seen him alive—barely alive—in Victor Babes' pediatric ward for the most gravely ill patients. He was one of the children for whom Dr. Griffo had given his most dire prognosis.

I stole a glance at Gabriel and it filled me with sickening remorse—and also surprise. There were none of the usual signs of the ravages of the AIDS virus on his face, which was the only part of his body exposed. He looked as if he were sleeping peacefully. I retreated from the scene, but I could not help but consider the photographic possibilities in the tragedy I had stumbled upon. There was something poignant and powerful in the loss of this child.

I went back outside. I asked Gabriel's uncle, still standing by his car, where the funeral was going to take place.

"In Bravu," he said.

Mihai Bravu, I learned, was a tiny village forty miles outside Bucharest. I asked Gheorge if he thought the family would allow me to photograph the next day's ceremonies.

"Why not?" he shrugged.

The next morning, my translator and I waited outside Victor Babes Hospital. Gheorge had offered to return to Bucharest after taking Gabriel home to Bravu and pick us up to take us to the village. I wasn't sure he would, or would be able to, follow through on his offer, so it was a welcome surprise to see his car pull up.

Arriving in Mihai Bravu, we found a bleak collection of muddy, impassable streets and rundown cottages. It was as if we were traveling on a passport to yesteryear. I learned there was one telephone serving the seven hundred inhabitants of the village, and it frequently failed to work. There were a total of twelve to fifteen motor vehicles in the town, I was told. Gheorge Iatan owned the only automobile in his extended family of about forty. Like the phone system, his car was constantly in need of repair.

We found the house where the family had gathered. On a small table surrounded by candles sat Gabriel's coffin. There were about thirty people in attendance, most of them standing. Feeling eyes turn on me, I resolved to act with diffidence, to make every effort to convey my respect for the grieving family. Later, I learned this was the second mortal loss for the Lixandrus. Twins, Marian and Gabriel, had been born to them in August 1988. Marian had succumbed to AIDS during the anti-Ceaușescu riots in December of 1989. Gabriel died a month later.

I was taking my camera out of my bag when an elderly woman, Gabriel's grandmother, approached me.

"We've been waiting fifty years for you," she said. She grabbed my hand and kissed it.

I was stunned. I asked my translator to ask her what she meant by what she said.

"We knew the Americans would come back," was her reply.

It sunk in on me that I was viewed by the grieving family not just as a photographer, but as someone representing my country, and somehow I had the responsibility to represent my country well. I knew nothing about the customs of the people in the village, just that I didn't want to do anything to violate them. So I resolved not to get too close to things with my camera, to shoot everything wide-angle from a respectful distance.

And yet they encouraged me to come closer. They asked me if I was thirsty, if I wanted something to eat from the pot of *mamalliga*, a traditional Romanian dish akin to polenta, simmering on an open-pit fire. They were treating someone who didn't look like them or dress like them or talk like them like an honored guest.

Another old woman urged me to approach the table where the body lay. Family members had placed cookies and worn, soiled bills of lei, the Romanian currency, in the coffin. There was also a bottle of water, a bottle of home-made wine, and sprays of flowers in the coffin—all that was needed, according to the beliefs of Gabriel's family, to get to the next stage of existence. I put two dollars in with the other donations and there was a palpable stir among the people around me. I later realized my contribution was probably worth more than all the rest of the money and goods combined. I wondered if I had made a mistake in becoming so engaged rather than remaining in the role of objective bystander.

After a series of prayers and a ritualistic pouring of wine and offerings of incense, the village priest walked with the small delegation to the church. The baby's coffin, still open, was placed on a horse-drawn wagon. The women, led by Gabriel's great-grandmother, mounted the wagon and began a ritual sobbing and rocking that continued all the way to the church.

In a village like Bravu, a funeral for one of their own would normally bring out the whole population and a procession of hundreds of people. But Gabriel and his twin had died of a disease that was believed to be virulently contagious. (AIDS is transmitted through bodily fluids, but few Romanians at the time, and certainly no peasants, understood how the disease spreads.) Only the family and a handful of very close neighbors walked the mile to the church.

It is not uncommon for a small village like Bravu to have its own church. The Romanian Orthodox Church has nineteen million adherents, or about 87 percent of the country's total population. Approximately 60 percent attend church services only once a month, once or twice a year, or not at all. But the faith is deeply ingrained in the culture. When the Communist Party came to power in 1947, it initiated mass purges that decimated the Orthodox hierarchy—as many as five hundred priests were sent to concentration camps. State-church relations thawed in 1962 when Romania adopted a more nationalistic policy to secure its independence from the Soviet Union. In a bizarre twist, many Orthodox priests went to work in secret for the Securitate, helping the state keep close tabs on local populations. Despite this history of collaboration with the communist regime, the Orthodox Church remains one of Romania's most trusted institutions.

As for Orthodoxy, Westerners often have a hard time grasping the exact nature of this religion. Traditionally, issues of social justice, health, and welfare have not been viewed as falling within the purview of the Orthodox clergy. But in recent years, some bishops and priests have sought to address these issues as matters for church involvement.

According to Victor Groza, an American of Romanian descent who teaches social science at Case Western Reserve University, the philosophy and theology of the Romanian Orthodox Church have led Romanians to value communality—family, neighbors, friends, and church—over individualism, and to nurture an inner life rather than the exaltation of external acts. The radiantly spiritual painted churches and monasteries of Romania seem to promote the virtues of meditation and brotherhood.

Yet in Bravu a decidedly uncommunal event was unfolding. The few villagers present along the route of Gabriel's funeral procession stood at a distance, and their body language expressed fear and hostility. I did not see a single observer make the sign of the cross as the casket passed. When I had my translator ask Gabriel's uncle why this was so, Georghe replied that the villagers were afraid their own children would become infected with the mysterious disease that had claimed the lives of the twins. None of the villagers wanted to get anywhere near the Lixandru clan. The Lixandrus had become pariahs in their own community.

A boy carrying a cross led the procession along the winding, muddy road. The cart followed the boy at some distance.

The entourage of mourners crowded in closely behind the cart. At one point the group's advance scattered a flock of geese. The disorder and dignity of the slow-paced march made me think of Christ's journey to Calvary Hill.

Bravu's small, ornate Romanian Orthodox church, decorated with richly colored murals and a domed ceiling, received Gabriel's casket. Within, in his impeccably white attire, the infant looked like one of Della Robbia's carved marble angels. It had been cloudy all day, but the sun came through a large arched window behind the altar just at the moment final prayers were being offered for his soul. From a photographer's point of view, it was one of those rare moments when all the elements of a compelling image come together. I knew the picture was there, with its universal theme of loss and redemption. I just hoped I had it focused correctly.

Gabriel's body was buried in the cemetery on the outskirts of the village. The matriarch of the clan, Gabriel's great-grandmother, visited all the graves of departed relatives to beseech them to ease Gabriel's passage from this world into the next.

The service at the graveside was simple. More wine and cakes were placed on the coffin, and a live chicken was passed over the grave three times before the casket was closed and the gravediggers completed their task.

In all the time I was with the Lixandru family, I never heard or saw Gabriel's parents speak to anyone. Their grief and their shame had separated them even from the members of their own family.

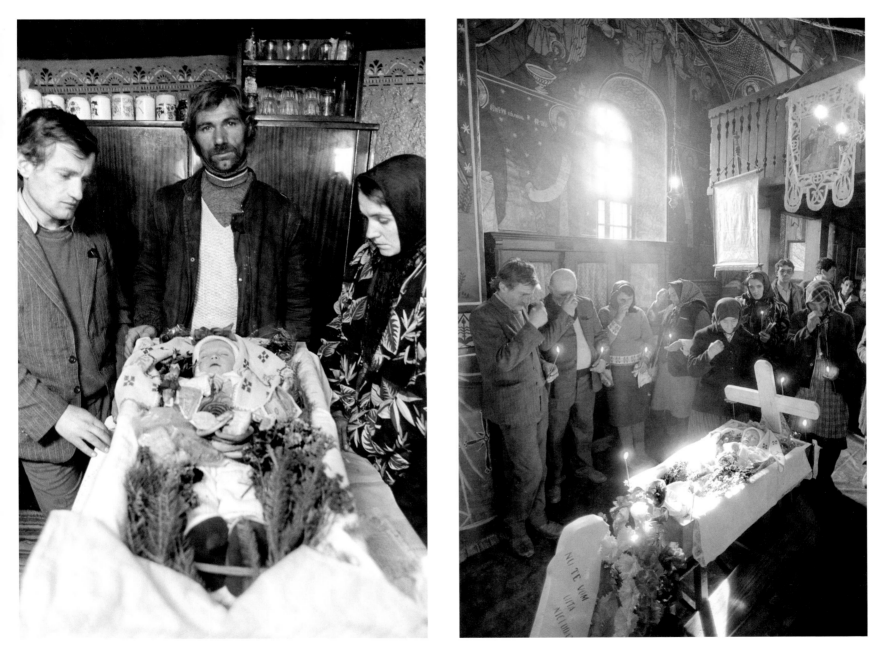

GABRIEL'S PARENTS AND UNCLE (CENTER) AT HOME, MIHAI BRAVU, 1990

FUNERAL AT ORTHODOX CHURCH, MIHAI BRAVU, 1990

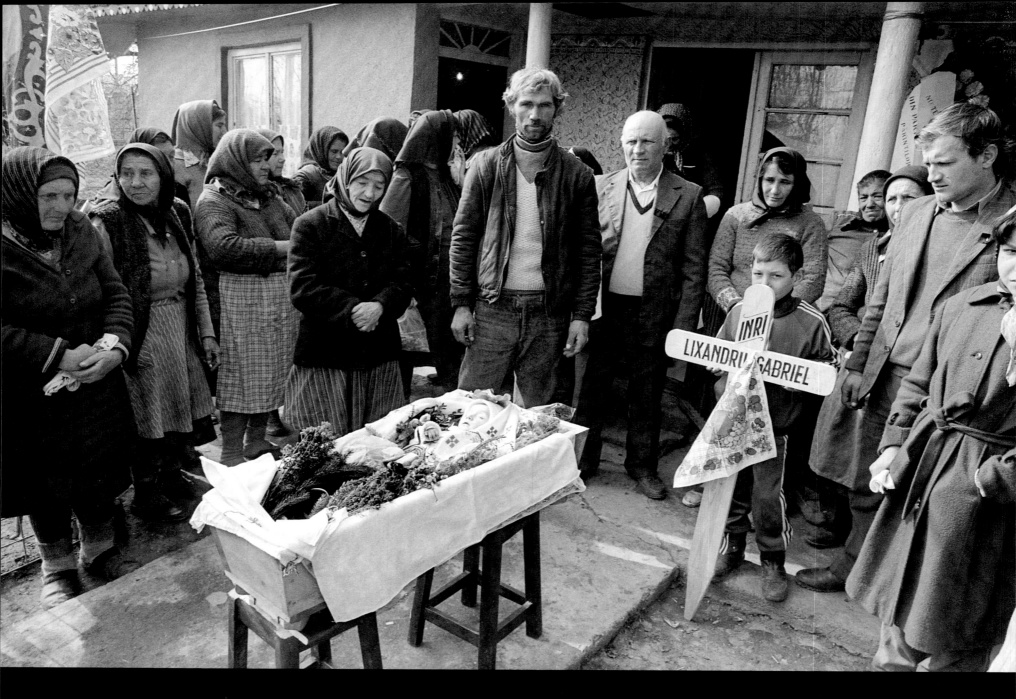

GATHERING AT LIXANDRU HOME BEFORE FUNERAL, MIHAI BRAVU, 1990

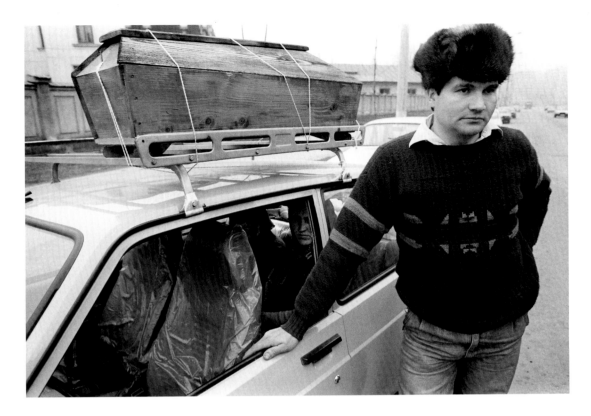

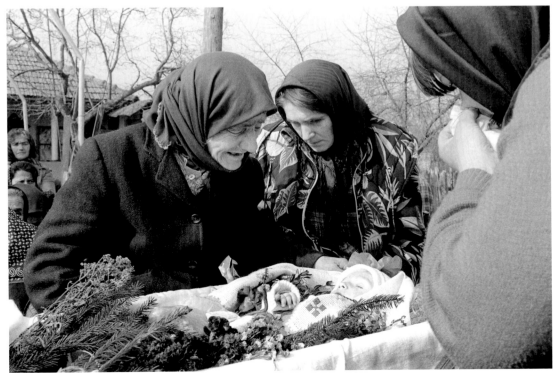

(TOP) GABRIEL'S UNCLE OUTSIDE
MORTUARY, VICTOR BABES
HOSPITAL, BUCHAREST, 1990

(BOTTOM) GABRIEL'S GRANDMOTHER,
MOTHER, AND AUNT ON FUNERAL
CART, MIHAI BRAVU, 1990

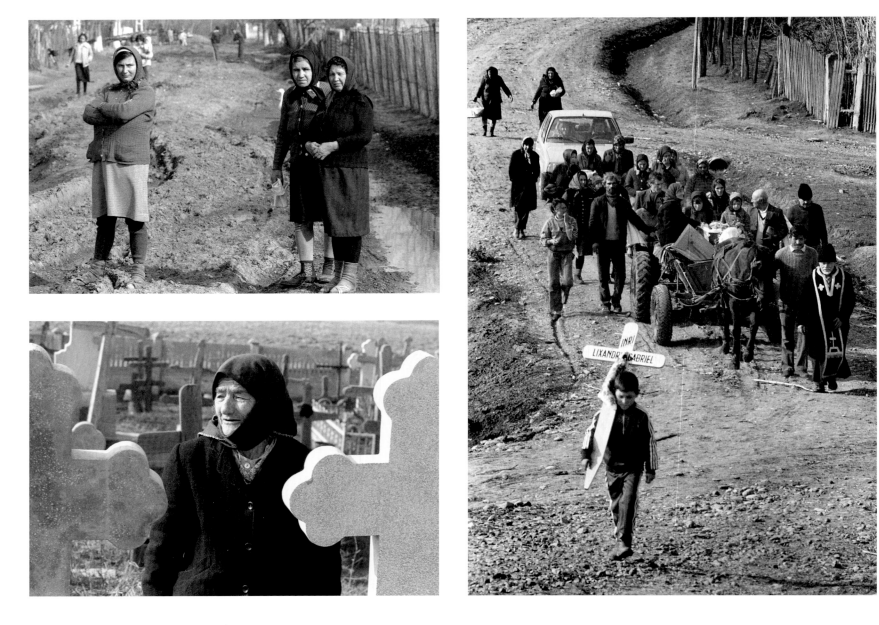

(TOP) VILLAGERS WATCH GABRIEL'S FUNERAL PROCESSION,
MIHAI BRAVU, 1990

(BOTTOM) GABRIEL'S GRANDMOTHER AT THE GRAVES OF
ANCESTORS, MIHAI BRAVU, 1990

PROCESSION TO CEMETERY, MIHAI BRAVU, 1990

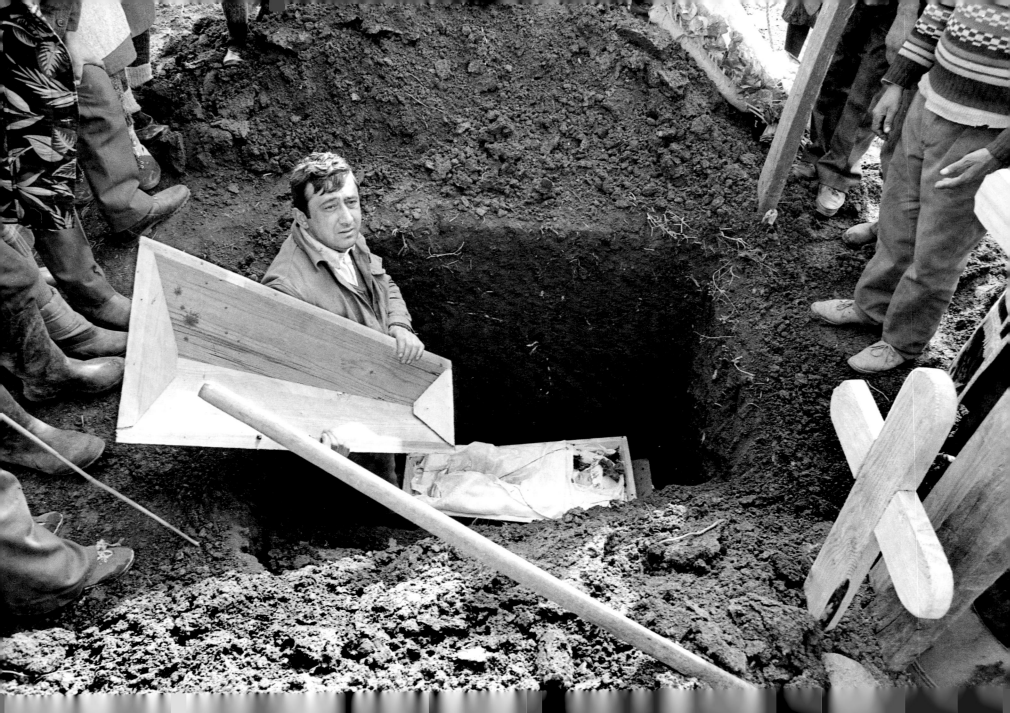

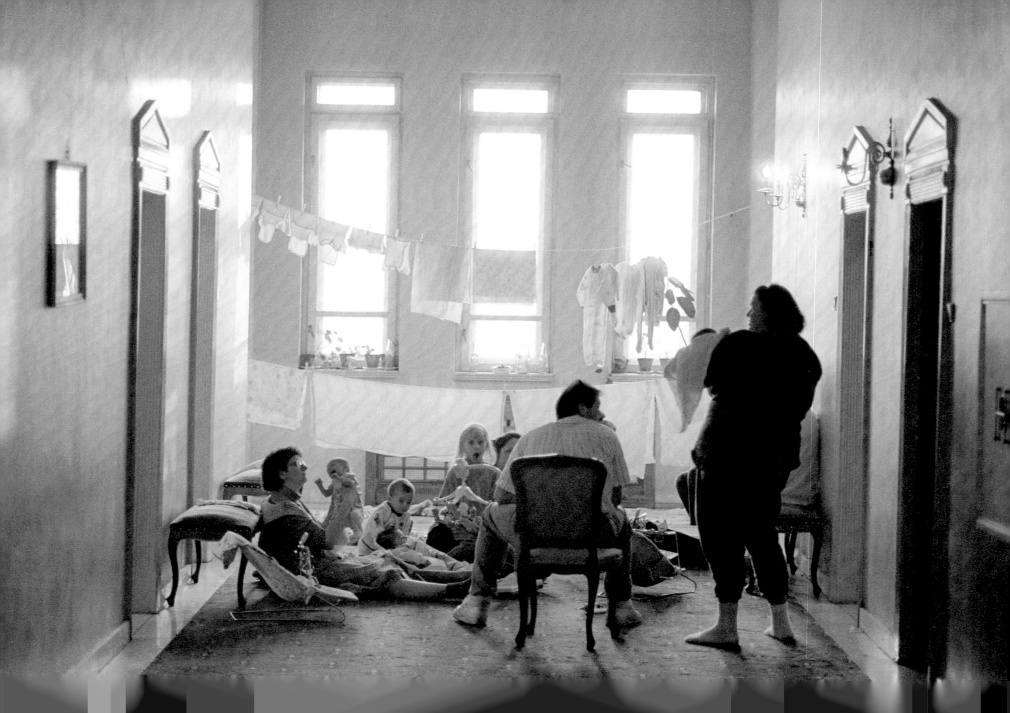

5. Babies in a Basket

MY ACCOUNT of Gabriel Lixandru's funeral in Bravu and my photographs of the children's hospital in Bucharest, which accompanied Dr. Bill Griffo's article on the pediatric AIDS epidemic in Romania, were published in the *Boston Globe* on Sunday, March 25, 1990. Within a week, my phone began ringing off the hook. Joan and I logged more than seventy-five calls from New Englanders who had seen the stories and wanted to help the lost children of Romania.

I was deeply touched, yet I had no idea how to channel the charitable impulses of so many people. At first I directed them to AmeriCares, the international relief organization I had partnered with on our fact-finding trip. That group was more than happy to accept any donations people might want to make, but the money would go into a general fund to be used to deal with natural disasters, such as floods and earthquakes, as they occurred anywhere in the world.

That wasn't good enough. Our band of early responders wanted action that would bring aid directly to the children depicted in my photographs.

Joan and I decided to invite the people who had contacted us to our house to discuss the situation. More than forty individuals from all walks of life crowded into our kitchen and talked about what could be done to help the children and staff at Victor Babes Hospital and Orphanage No. 4 in Bucharest. We concluded that we would form a group to collect medical supplies and children's toys to ship to Romania. At the end of the meeting we were a relief organization, at least in name.

The early stages of the new aid group, which we named Romanian Children's Relief (RCR), were chaotic. With the help of church and civic groups, we collected thousands of dollars' worth of materials, from diapers, nurses' smocks, and medical supplies to computer software and teddy bears. Joan and I conducted tag sales in our front yard to raise the funds needed to ship the materials abroad. I wangled magazine assignments in Bucharest and Prague so I could oversee the distribution of the aid supplies once they reached Romania.

We discovered that information was one of the most potent agents for change that we could provide to Romanian

caregivers. (The doctors we encountered on our first visit begged for copies of the *Physicians' Desk Reference*, a manual that carries information on more than four thousand drugs.) A Boston nurse with experience in treating AIDS developed an instructional package for dealing with the disease at the institutional level. A New Hampshire neonatal pediatrician created a manual for incubation and resuscitation procedures for the maternity wards in Romanian hospitals. A pharmacist set up protocols for Romanian doctors and nurses to follow in regulating drug dosages for patients.

Sometimes our naivete got the better of us. When a local physician offered to give us the samples of antibiotics he routinely received from drug companies, we had the brilliant idea of soliciting samples from other doctors, only to discover, in time, that this practice was quite illegal.

My follow-up trips to Romania also revealed that there was a fair amount of venality and corruption choking our supply lines. The medical materials we worked so hard to collect sometimes disappeared, probably sold for profit on the black market. Our shipments of clothes, toys, and medical supplies were often appropriated by caretakers for their own families. The crowning blow came when I met an orphanage director and discovered she had held back dozens of teddy bears from a relief shipment so that she could decorate her office with them.

Meanwhile, another crisis was developing that involved the lost children of Romania. In the wake of widespread published reports following Ceauşescu's downfall on the existence of tens of thousands of Romanian orphans, would-be parents flocked to Bucharest in search of children to adopt. This set in motion a pattern of greed, corruption, and deception that would gravely damage the "new" Romania's reputation in the eyes of the world.

I myself was not immune to the emotional appeal of the abandoned children. While covering some of the more scandalous aspects of the brief but widespread adoption frenzy, I happened to be taking photographs in the maternity ward of a hospital in Ploiesti, about twenty-five miles north of Bucharest. Jumping up in his crib, a little boy named Ionut smiled at me as I passed by, and my heart leaped out to him. The handsome, sandy-haired two-year-old, I learned, had been abandoned by his mother, who had moved and left no forwarding address; his father was in prison. Ionut was a child in limbo, and without someone to care for him, he would probably be sent to an orphanage.

Much, much later, in developing a coherent philosophy for running Romanian Children's Relief, I came to realize that emotional attachment is important to those who would help others, because one needs to be humane to care in the first place. But too much attachment interferes with good judgment, and that was certainly the case when I made the on-the-spot decision to adopt Inut.

This was crazy. I had not even consulted Joan, or our own two kids. In any case, fate intervened. When I returned to the hospital the following day, Ionut was gone. A doctor told me that the child had tested positive for hepatitis B and HIV. If this were true, I could not legally bring Ionut into the United States anyway. My adoption fantasy began to fade. It ended definitively when I went to see Ionut at the infectious-disease hospital in the city of Colteau, to which he had been removed. I never did find him.

A friend of mine, Lee Aitken, for whom I had done freelance jobs when she was an editor at *People*, had come to

Romania at this time in hopes of adopting a child herself. I followed her around during this weeks-long ordeal and obtained a disturbingly candid view of an adoption process run amok. It was a shattering experience for Lee, and she later wrote about it movingly for *People*'s sister publication, *Money*. Basically, she was duped by a thuggish ex-taxicab driver who introduced her to a sweet fourteen-month-old girl who needed a home, gave her custody of the girl for days at a time, during which time Lee understandably became smitten with her, and finally sold her off to a higher bidder in a classic bait-and-switch scam. There was a happy ending, in that Lee did find a wonderful child to adopt months later—in Bulgaria. But her ordeal in Romania was one that neither of us would ever forget.

"In droves, Americans, Canadians and Western Europeans came to save a child," Lee wrote in her article for *Money*. "They arrived with a carton of medicines for the orphanage. They smoothed the path through Romania's creaky bureaucracies with small tokens—cigarettes, lipstick, chewing gum—and were usually moved to give the impoverished birth family $400 or $500. All told, for a few thousand dollars, including air fare, they returned home after several weeks with a new family and a sense of virtuous accomplishment."

But by the time Lee reached Bucharest in February of 1991, the collision of Western wealth and Eastern Bloc poverty had created a burgeoning black market in babies. The document that could have been expedited for a carton of Kent cigarettes six months earlier now cost $50 to $100. People came on the scene as self-appointed baby brokers and began to charge $4,000 to $6,000 to find adoptable children. I saw several such wildcatters in action at the El Presidente Hotel in downtown Bucharest, including a waitress from Vancouver and a nurse from Minnesota, both of whom had quit their day jobs to move to Romania to trade in babies.

"Yet even as the costs soared, they still seemed like a bargain to people who knew that adoptions could run from $12,000 to $15,000 in Latin America," Lee observed. "So they paid up without giving much thought to the fact that it would take a Romanian professional five years to earn $5,000. But such cocaine-size profits attracted sharks, too—people who forged documents and bullied birth mothers to complete an adoption. In the last crazy phase of the baby lift," Lee continued, "the futures of parents and children ended up in the hands of people you would not buy a watch from."

In one hotel Lee and I came across an operation we called "Babies in a Basket." An American woman was brokering $6,000 babies out of a suite. We saw three bedded down in cardboard cartons, a fourth in a bassinet. When the woman saw me with my camera, she chased us out of the room. The adopters, sitting in the hallway outside her door, were hostile, too. They had decided to ask no questions about where their children came from.

We also witnessed trafficking in the streets of Bucharest. Roma women offered babies for sale outside the so-called Phone Palace, a telephone exchange used by foreign visitors to place long-distance calls. One little girl, no parents in sight, was being sold off the sidewalk for a car, a VCR, and $1,200 in cash. I witnessed another transaction in which a Gypsy male offered to throw in a live chicken to close a deal on "his" baby.

Although I didn't know it at the time, Eileen McHenry, who would become RCR's executive director, was right in the middle of all this chaos. Some years later, Eileen would

draw on her experience in the business world to put our organizational house in order and, perhaps even more important, would draw on her own experience in adopting a child in Romania to infuse all her efforts on our behalf with a humane and compassionate perspective.

Eileen was thirty and her husband, Mike, was thirty-three when the couple traveled to Romania in May of 1990 in hopes of adopting a child. This was only a few months after my first visit there with Dr. Bill Griffo and the team from AmeriCares. (Eileen had read our accounts in the *Boston Globe* about the abandoned children in the country's hospitals and orphanages.)

Eileen and Mike did find, in a hospital in Ploiesti, a wonderful girl to adopt—the blue-eyed one-year-old Juliana. But the six-week period Eileen spent in the country to complete all the necessary documentation for the adoption was a nightmare, in her words, "an endless round of disappointments and misunderstandings about the status of Juliana's papers." To make matters worse, the baby fell ill with a croupy cough and a high fever. Then, on May 30, a severe earthquake struck Ploiesti while Eileen was visiting.

"Later that day," she recalls, "I had to take Juliana for a battery of medical tests required by country authorities. My nerves frayed from the earthquake, I almost lost control when they submitted her to a strange brain-wave test that had no apparent medical purpose. She screamed the whole time, throwing the readings off, and they repeated the test three times. I grabbed Juliana from the technicians and told them I thought their methods were archaic, stupid, and sadistic! Thank God they didn't understand English."

After decades of communist misrule, living conditions in the capital city, where Eileen was staying, were horrible.

"The grim reality of Romania had taken its toll," she relates. "I got sick myself for a while. I couldn't remember when I'd last had fish or fruit." In the square outside her hotel, night after night, thousands of demonstrators gathered to protest the provisional government of Ion Iliescu, by all accounts as bad a character as the deposed Nicolae Ceauşescu. Ironically, the McHenrys needed President Iliescu's signature to complete their adoption of Juliana. In response to the street riots, Iliescu transported coal miners into the city to "defend" the country from the demonstrators. "Now there were workers everywhere," Eileen remembers the scene, "thugs, really, armed with sticks and poles." Some demonstrators were killed and the administration arrested candidates from two opposition parties before a fragile peace was restored.

Only her visits with Juliana preserved Eileen's sanity during this chaotic time. "It was a thrill to be getting to know my future daughter and to start helping her overcome the months of deprivation and neglect," Eileen recalled in an article for *Ladies' Home Journal*. "We'd go outside, and when I put down a blanket so that she could sit, she never strayed over the edge—I don't think she knew what the grass was. And when I put toys around her, she didn't know how to play with them. She just clutched her hands together and inhaled with glee. She wouldn't touch the toys unless I encouraged her. But then she would smile—and her smile always melted me."

Eileen's firsthand experience of the catastrophe that had befallen the abandoned children of Romania would prove to be invaluable in guiding the efforts of Romanian Children's Relief and its in-country partner, Fundatia Inocenti.

Meanwhile, news that the adoption process in Romania had gotten completely out of control soon reached the out-

side world. It had come to the point where babies were being snatched from the arms of new mothers in maternity wards and adopted directly out of rural huts, safe houses in cement tenements, and the backseats of cars. Under pressure from the European Union and humanitarian groups, the Romanian government imposed strict new limits on adoptions by foreigners, and the result was soon felt. According to Romanian Adoption Commission statistics, the number of foreign adoptions dropped from a high of 7,410 in 1991 to a low of 210 in 1992. (More than 2,300 Romanian children were adopted by Americans in this period, and some 700 by Canadians.)

Our relief organization flirted briefly with the idea of helping American families adopt abandoned Romanian children. But after what I had seen happen to Lee Aitken, I was firmly opposed to our involvement. For one thing, adoption had not signicantly reduced the number of orphans languishing in institutions. In fact, one-fourth of the children adopted during this period were under the age of six months and came from poor families, not institutions.

In spite of the often sordid circumstances under which it was conducted, adoption had provided loving homes to many hundreds of needy children, as Eileen and Mike McHenry can attest. But tens of thousands of needy children remained behind in Romania. That population, I decided, must be the focus of our work.

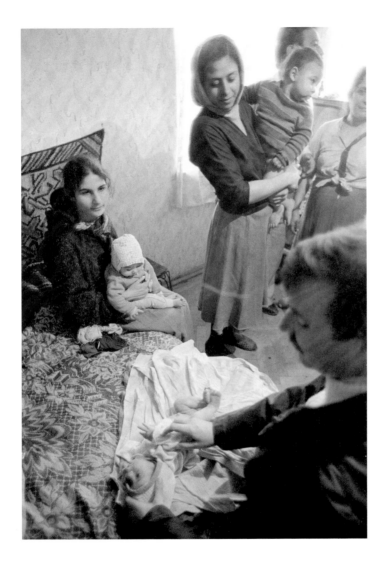

ADOPTION IN VILLAGE EAST OF PLOIESTI, 1991

(TOP) A LIVE CHICKEN FIGURES IN ONE ADOPTION, CITY HALL, PLOIESTI, 1991

(BOTTOM) BUNDLES OF ROMANIAN LEI USED TO PURCHASE BABY, BUCHAREST, 1991

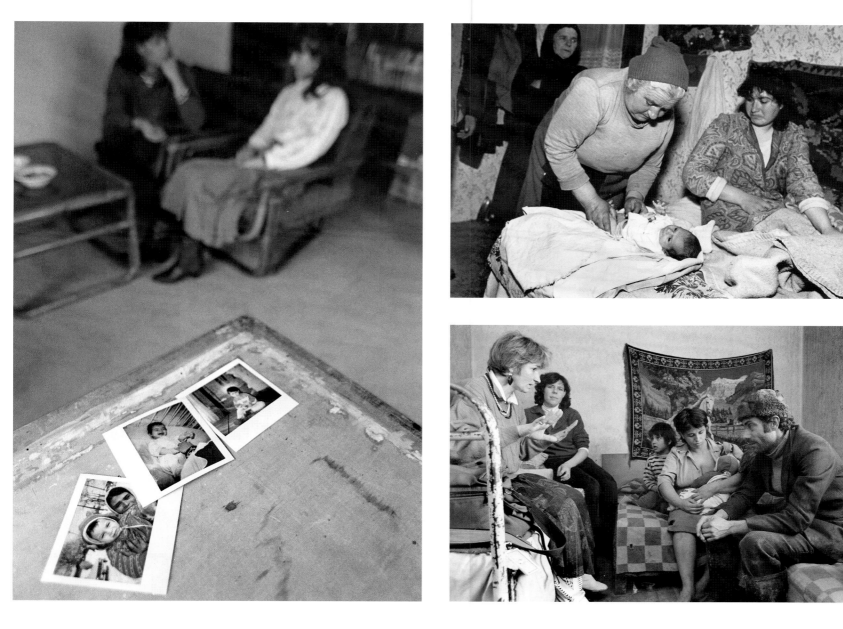

POLAROIDS OF BABIES ELIGIBLE FOR ADOPTION, BUCHAREST, 1991

(TOP) GRANDMOTHER AND MOTHER WITH BABY PUT UP FOR
ADOPTION NEAR BUZAU, 1991

(BOTTOM) LEE AITKEN (SECOND FROM LEFT) WITH INTERPRETER
NEGOTIATING FOR CHILD ON COMMUNAL FARM NEAR BUZAU, 1991

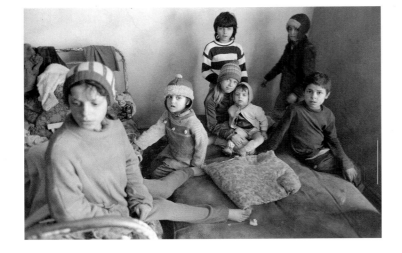

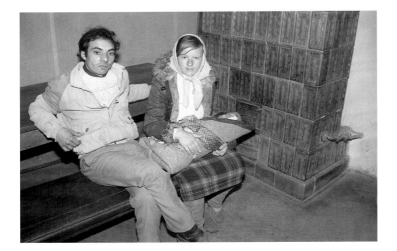

(TOP) CHILDREN LOOK ON DURING ADOPTION
NEGOTIATIONS NEAR BUZAU, 1991

(MIDDLE) PARENTS GIVE UP CHILD FOR ADOPTION
AGAINST THEIR WISHES, TOWN HALL, PLOIESTI, 1991

(BOTTOM) CHILD OFFERED ON THE STREET FOR
ADOPTION FOR $600, BUCHAREST, 1991

LEE AITKEN WITH ABANDONED BABIES
AT MATERNITY HOSPITAL, PLOIESTI, 1991

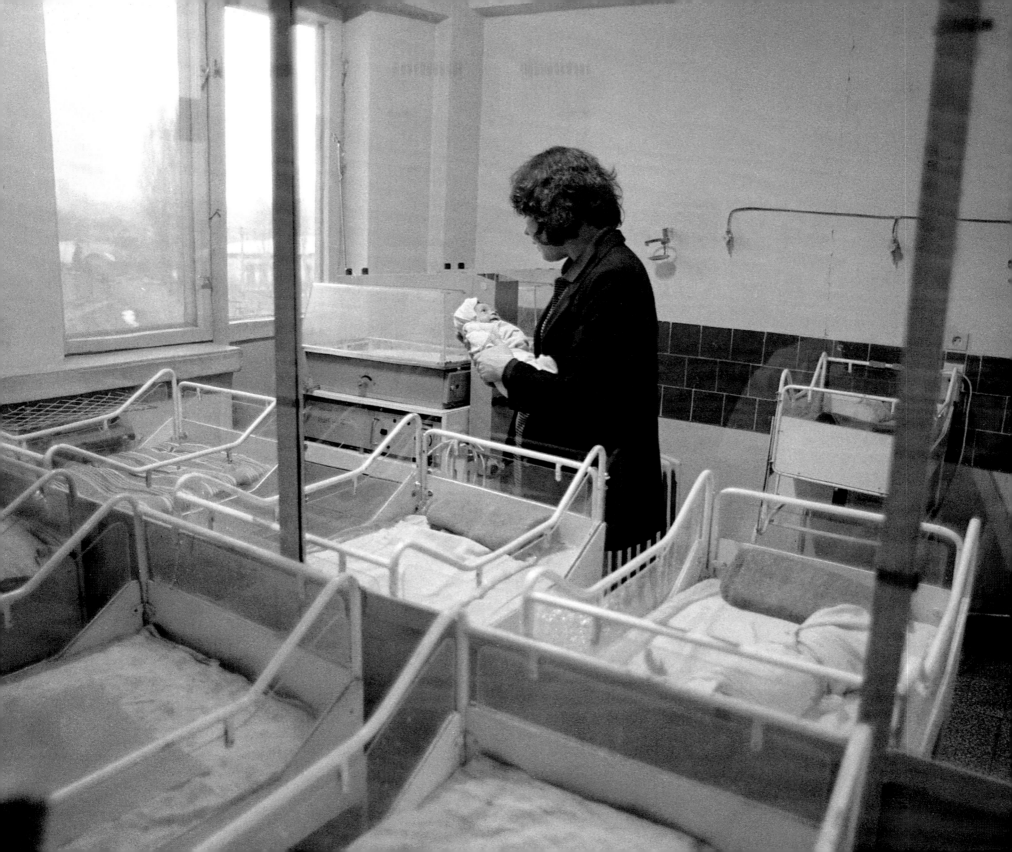

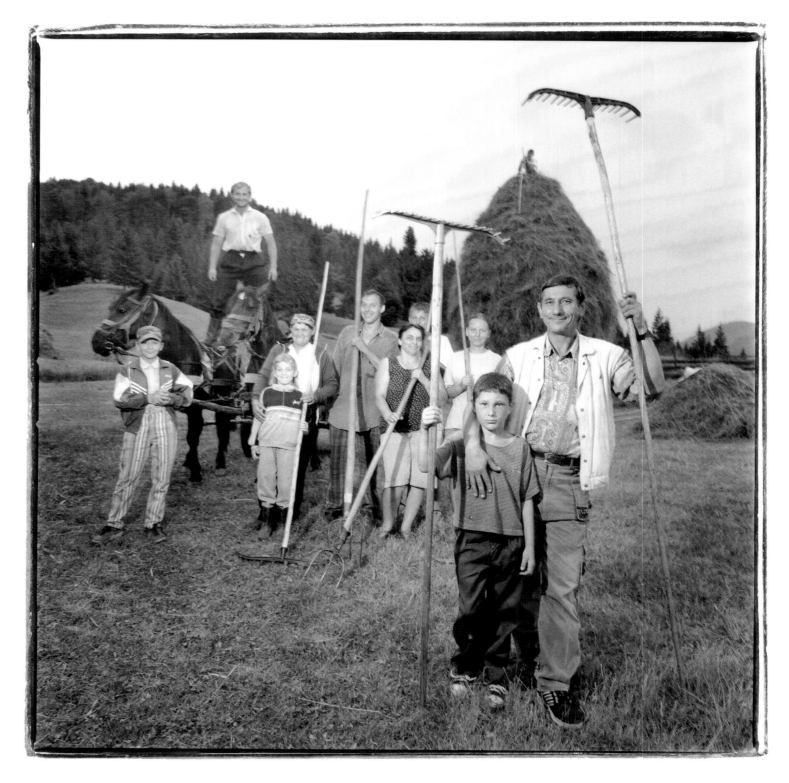

FOSTER FAMILY,
COLIBITA, 2002

6. The Foster Care Solution

MY EARLY PHOTOJOURNALISM in hospitals and orphanages was not necessarily popular with Romanian officials. But to me it was a matter of photographing what was real, and at the same time picturing what might be possible, in its place.

I use my camera as a kind of passport that allows me entry into the lives of others. Sometimes I think of it as my pen or paintbrush. The camera makes it easy for me to be with someone, and at the same time it allows me to penetrate and document their world.

Of course, there are times when a camera is unwelcome. In 1991, the woman dealing babies for profit out of her suite of rooms in El Presidente Hotel in Bucharest definitely did not warm to an inquiring photographer in her midst, nor did the adoptive mothers anxiously waiting for babies. Lounging about outside the baby broker's door in the hallway, they stared at me with unabashed contempt.

And generally speaking, as we have learned in the age of full disclosure, all paparazzi are anathema to all celebrities.

With those exceptions, I find the average person, and especially children, receptive to me when I am brandishing my photographic equipment. The camera has been especially valuable to me during my travels in Romania, breaking down barriers caused by language and by my status as a foreigner. My clothes and even my beard mark me as an outsider. There were not many bearded Romanian men at that time. Being both male and a male with a beard made me a novelty in the eyes of the orphans I encountered. Some children were terrified of me, while others were so curious they reached out to touch my face and stroke my beard.

Yet my camera had the power to bring strangers together. Most kids love to have their pictures taken, so I've made it a point to oblige them when I'm in their company. Earlier I mentioned that I carry around a Polaroid camera expressly for the purpose of presenting children with instant portraits of themselves, images they can keep and show to others. For some kids this modest gift means everything—it gives them the identity they have been denied by the harsh circumstances of their early years. With my digital camera I sometimes produce impromptu slide shows of kids in action

on a playground or in a classroom. I let older children look through my lenses and take their own pictures. Sometimes my equipment takes a beating, but it's worth it.

I like to have my subjects participate in the making of the photograph. I believe that it is their image as much as mine. I handle the technical parts—the camera settings and such. I compose the picture and, with any luck, infuse it with life and relevance. But my subjects have to play the central role in the process.

Naturally I enjoy taking photos of our RCR staff working with children in hospitals, clinics, and schools. I am especially proud of a series of family portraits I made in the homes where dozens of our foster children had been given a new lease on life. One after another, the portraits underscore the values—honesty, hard work, and helpfulness—of the extended-family lifestyle that has been the greatest strength of Romania's rural farm culture. And if the family pig is in the shot, so much the better. It is ironic that the countryside Ceaușescu sought to despoil and depopulate during his years as head of state has proved to be one of the best agents for helping the abandoned children he brought into being.

When the Romanian government placed a moratorium on adoptions in the early 1990s, there was a sea change in the role of not-for-profit aid groups (nongovernment organizations, or NGOs) in the country. Some NGOs reduced staff, others pulled out altogether. The adoption issue was not the sole factor in the sudden decline of support. As happens almost every time a natural or man-made catastrophe afflicts a people or region, the initial groundswell of humanitarian outreach diminishes as new catastrophes appear on the scene elsewhere in the world. "There you go again," was the disappointed response of many Romanians to the downswizing of NGOs from the West. "Here today, gone tomorrow"—another promise broken.

In the case of RCR, we were experiencing some growing pains ourselves. Our first setback came, as mentioned earlier, with the realization that some of our material donations had never reached the children we were trying to help. But there was also an underlying conceptual fault in this approach. If I give a child a toy or a game, I experience directly the pleasure of giving and vicariously the joy the child feels in receiving that gift. If I give somebody $50, say, to provide love and attention to that child, I don't get emotional feedback from that gesture, unless I understand it at a different level. I came to understand that much of the aid flowing into the country in the early years of the orphan crisis was for naught, because the children were still stuck in their institutions. They had food. They had clothes. They had toys and books. But they still didn't have the human interaction necessary for healthy, normal development.

To bridge that gap, we recruited a young man named George Lang to run an organized play program in the pediatric ward of Rusescu Hospital, located in one of Bucharest's poorer neighborhoods. George had studied Child Life, today considered an essential component of quality pediatric health care, at Wheelock College in Boston. The Child Life curriculum produces specialists in child development, who help children cope with the effects of stress and trauma through play, preparation, education, and self-expression activities. Using toys, games, puzzles, and other educational materials, George converted a small room on the floor of the ward into a playroom (today we have three playrooms in Rusescu Hospital). He brought small groups of the hospi-

talized children into the playroom for daily interactive play sessions, and in just a matter of months, doctors and nurses in the ward, some of whom had been skeptical of Child Life at the outset, reported seeing real progress in the children—more alertness, more activity, more talking.

For a while our in-country leadership suffered from a lack of continuity—we went through several directors in four years. We were more successful, using the Peace Corps as a model, in attracting young Americans to spend two-year terms in service in our programs in Romania, providing them a modest but meaningful stipend at the end of their tenure, with which they could pursue education and career back in the States. Similarly, we accepted American students as volunteers in various programs for short periods of time coinciding with their school vacations. In retrospect, these short-term solutions gave young people invaluable experience in working with the needy, but the abandoned children of Romania were, in effect, abandoned again as soon as these helpers left for home. It was clear to me we needed more and longer continuity on the ground, with more native Romanians on staff as paid professionals and volunteers.

We also learned the importance of briefing our staff members and volunteers on the media and how to talk to reporters honestly but with discretion. A few years ago, when several college students from the Boston area came back from volunteer work in pediatric wards in Romania, one told the *Boston Globe* of playing with "hot and sticky babies," a quote picked up by the Romanian paper *Ziua*. The hospital director was so upset we decided to cancel the next group of volunteers due to go over. After the director calmed down, we pointed out that babies do get hot and sticky in rooms lacking air conditioning and that the

student's comment was not intended as a criticism. Our program was soon reactivated: the director realized that the real public relations disaster would be a decision to withdraw our presence from his hospital.

We were determined to get RCR back on track in spite of our missteps. We developed the philosophy that every bump in the road was an opportunity. But I had a personal problem by the year 1994: I was going broke. I was spending so much time on the work of the aid group both in Romania and back home that my income as a freelance photographer had dropped by a third for three years in a row.

More distressingly, I wasn't spending enough time with my family. For instance, my son, Brendan, played on a basketball team that was like the Hoosiers in the movie of the same name—a terrible team that somehow started winning. I was the coach who never had time to go to the game. In the final game of the season, his team won in double overtime, and I wasn't there. In fact, I didn't even find out about it until two weeks later.

My daughter, Devon, knew me for a time as the guy who brought home dolls for her from abroad.

In this situation, I had to pull back from RCR activities, start making money, and spend more time with the family. At the same time, I knew I could not turn my back on RCR completely. I would disappoint so many people, like the woman who had sent us $40 a month (and still does, now going on twenty years), if I did.

My family made it possible for me to continue in what they undoubtedly thought at times was my quixotic pursuit. Collectively, they realized that the best thing was for everybody to be involved. With the kids in school, Joan went back to work, adding the income (and health care coverage)

we badly needed. She also began to draw on her knowledge in the fields of early education and child development to help me and our staff better understand the challenges we were facing in Romania.

In a way, Joan Peterson (justly proud of her Norwegian heritage, she kept her name following our marriage) had been in training for this role for years. She majored in social work at the University of Minnesota. Summers, she worked with "at risk" Native American children. Following graduation, she studied to become a Montessori teacher at Fairleigh Dickinson University in New Jersey. She also received degrees from the New School and Northeastern. She started a Montessori day care center for working mothers in Teaneck, New Jersey, and, after we moved to Massachusetts, she started a Montessori program in the public schools in the town of Harvard. Today, Joan works as an early intervention specialist and special needs coordinator for the Littleton, Massachusetts, school system.

Long before Joan visited Romania herself, she helped me make sense of what I was finding in the pediatric wards and orphanages on my various trips. When I told her how shocking it was for me to see the total lack of affect in the abandoned children, she explained what happens, or rather what doesn't happen, to children left in institutions without stimulation or affection. On her first visit to Romania in 2001, she saw at once that most of the children we were trying to help were profoundly nonverbal. This realization led directly to our development of an early-literacy program the very next year. Joan ran the training sessions for the staff members and volunteers, people who would go into hospitals and homes with reading materials—with the gift of literacy.

We had decided it was important to introduce our own children to RCR's activities in Romania at this difficult time in the country's transition from communist rule and also a challenging time for us as a family.

Brendan came over with the son of a good friend of mine, Bill Breidenbach. Bill and I thought the trip would do them good—like almost all young teenaged men, Brendan and Dan were on the verge of getting into trouble of one kind or another. As it turned out, they never adjusted to living on Bucharest time. They slept until early afternoon every day. One day we arranged for them to rouse themselves, grab a taxi, and meet us at the hospital where we had an RCR program in development. But the boys forgot the name of the hospital and spent hours wandering city streets, lost and confused.

On a positive note, Brendan and Dan spent a good deal of time with the boys at Orphanage No. 9. Brendan videotaped the activities of the orphans for one of his school projects, a "day in the life" treatment that was well received by his teachers and classmates. The documentary included interviews with teachers at the school next door to the orphanage that many of the orphans attended. One poignant moment occurred during the interview of a teacher who had been demoted for political reasons from her position as a university mathematics professor during Ceaușescu's time in power. Reflecting on her reduced standard of living, she burst out crying as she related how long she had to save up to buy a new white shirt for her husband.

Devon turned sweet sixteen while we were staying in a Bucharest apartment that might be described as downscale if one was being kind. All she wanted for her birthday, Devon told her mother, was a hot shower in a clean hotel

room. The only present she got on that busy trip was a new pair of sunglasses, presented to her by a homeless Romanian girl who worked in a city circus. The glasses were undoubtedly stolen by this streetwise girl who had never had a birthday of her own.

One day, like Brendan, Devon also found herself alone and disoriented in the streets of Bucharest, due to a mix-up involving a taxi fare dispute. At this time, packs of wild dogs lived in the city, cowering under cars by day, roaming openly at night. Devon remembers being terrified of walking on the sidewalks. So much for sweet sixteen. And yet her exposure to the orphans we were trying to help made a deep impression on her. Years later, while studying to become a psychiatric nurse practitioner at Yale Nursing School, she told a friend, "My experience in Romania meant more to me than I thought at the time. It had a lot to do with my decision to study nursing and to work in the field of mental health."

With adoptions on the wane, we realized that properly managed foster care was an important option in our effort to get kids out of orphanages and into good homes. Many of our successful placements have been in and around Bistrita, Transylvania, in the northern part of the country. With a population of 80,000, Bistrita is the capital city of Bistrita-Nasaud County. A river of the same name, meaning "limpid waters," flows through the city; verdant hills and snowcapped mountains dominate its skyline.

In medieval times Bistrita flourished as a trading post. Its curious coat of arms, featuring an ostrich with a horseshoe in its beak, dates from that time. In Bram Stoker's novel *Dracula*, the character Jonathan Harker visits Bistrita and stays at the fictional Golden Krone Hotel. Since then a real hotel of the same name was built in the city to attract tourists on the trail of Count Dracula. (Vlad the Impaler, on whom the fictional Dracula was based, was born in Transylvania in 1431 and became prince of Wallachia, present-day southern Romania, in 1448. The Romanian actor Bela Lugosi famously portrayed Dracula in one of numerous films about the world's most notorious vampire.)

Our programs in Bistrita, which by 2006 had received full accreditation from the Romanian government, were originally funded by Rotary Clubs in Massachusetts. Dennis Irish, a health-care industry executive who was president of Worcester's Rotary Club, was interested in RCR's activities and decided to join me on a trip to Romania in 1995. There, he arranged a meeting with the president of Bistrata's Rotary Club, a Dr. Buta, who happened to be in charge of the pediatric wing of the Bistrita-Nasaud County Hospital in the city.

That first contact led to numerous programs to help abandoned children in the Bistrita area, perhaps most notably helping the newly formed government agency, the Department of Child Protection (DPC), with support services for some 240 foster children and their families. Foster care provides a much more beneficial alternative to life in so-called placement centers—bland, state-run environments offering little or no physical, mental, or emotional stimulation. We also established Child Life playrooms in Bistrita Hospital, where children in the pediatric ward enjoy play sessions with volunteer aid workers and have access to educational and art materials, a maternal center for counseling single moms, and a recuperative services center staffed with a speech therapist for assisting the many orphans with poorly developed verbal skills.

Older children pose a special challenge for relief workers. They are harder to place in foster care simply because families are disinclined or unable to cope with older kids with psychological problems. For emotionally and developmentally disabled teenagers, the DPC established group homes, with our RCR staff providing support services, in the towns of Chirales and Nasaud, not far from Bistrita.

Most of the youngsters in the Nasaud facility, which was located next to the village church, came from Beclean Camin Spital, a hospital nominally intended for handicapped children and adults but woefully inadequate in services to address the needs of the handicapped. When they first arrived, the youngsters from this facility were unable to talk, dress themselves, or eat with forks and spoons. As some kids started talking, stories of neglect and abuse poured out of them. One child was taught by a particularly malicious "caregiver" at the Camin Spital to use obscene words instead of normal language to communicate. Within a year, however, the boys had all learned to sit at a dining room table and politely dine. They enjoyed exercise in a playground and on walks to the village. Puzzles, games, and music therapy helped them build basic cognitive skills.

To involve the local community more directly in our efforts, we began an annual one-day competition in Bistrita called Olympics of the Innocent. (RCR's Romanian counterpart is called Fundatia Inocenti.) It is modeled after the Special Olympics, with sports like soccer, bowling, handball, and table tennis, only it also includes contests in art, music, and dance. By its third year, the games were a huge success, involving more than 350 participants, 75 or 80 volunteers, and hundreds of townspeople as spectators. The immediate goal of the event is to give the children a chance to have fun. The larger goal is to show the community the potential of kids with disabilities, to show how much we value these children, and to fight against their marginalization by society.

Every child taking part in the games receives a hat, a T-shirt, a certificate, and a medal. I've seen kids break into tears of joy when they are awarded their medals. One year, players on a victorious soccer team carried one of their teammates, a Down syndrome boy, on their shoulders after a match. The boy had contributed little or nothing to the team's success on the field, but his expression radiated such happiness that he might as well have scored the winning goal.

No one goes home a loser in the Olympics of the Innocent.

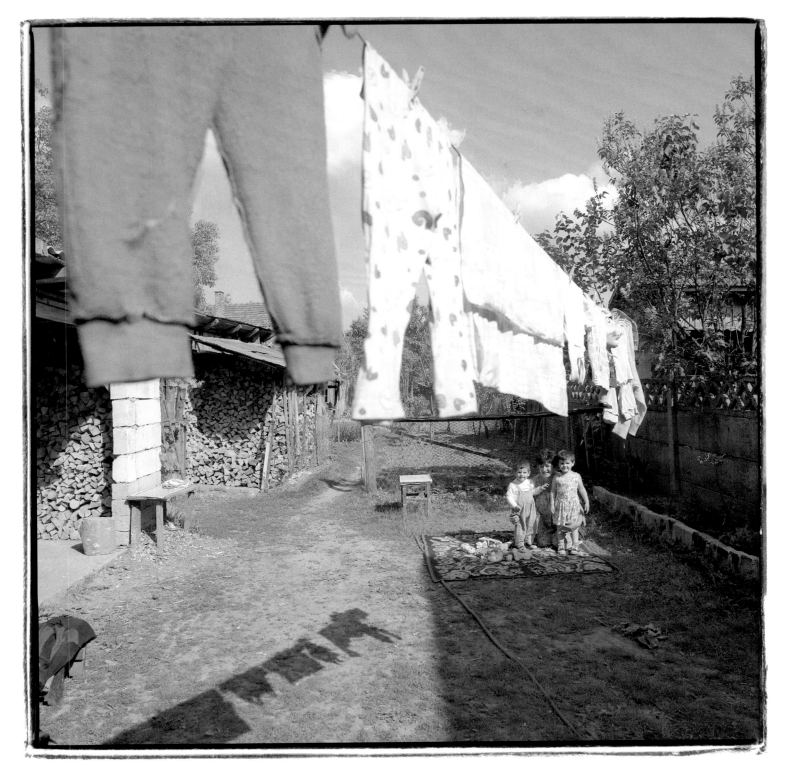

FOSTER FAMILY,
BECLEAN, 2003

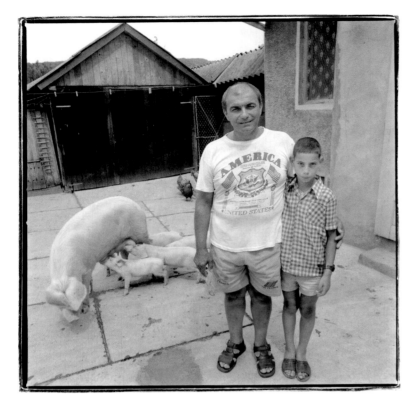 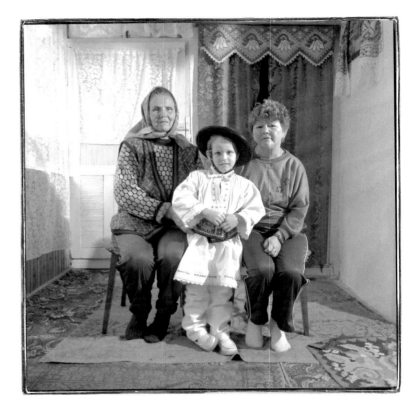

A Foster Families Photo Album

ROMANIAN CHILDREN'S RELIEF began working with orphans and other abandoned children who were placed in foster families by the Department of Child Protection beginning in 2000. The goal of the program was to expose the children to healthy family environments where their physical, emotional, and cognitive skills and faculties could be nurtured. It was hoped that the negative effects of their lives in the deadening atmosphere of institutions would gradually diminish and the children, even those with severe handicaps, would begin to experience the joys and challenges of a normal childhood. As I witnessed one successful placement after another in this program, I wondered how I could document some of these successes. I decided to make portraits of the children in the context of their new homes. What follows are some of the group portraits I took during this period. Each one tells a slightly different story, depending on the setting, the age and number of the family members, and, very often, the animals living on the premises, ranging from pets to porkers. But what unites the images, I think, is the feeling of contentment and well-being that seems to envelop each family.

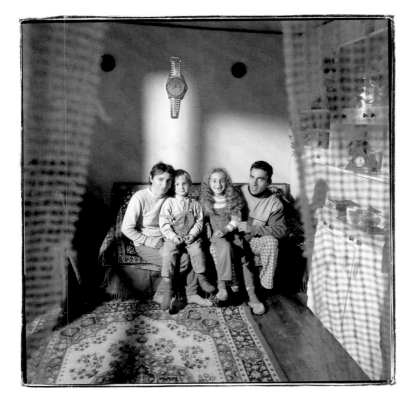

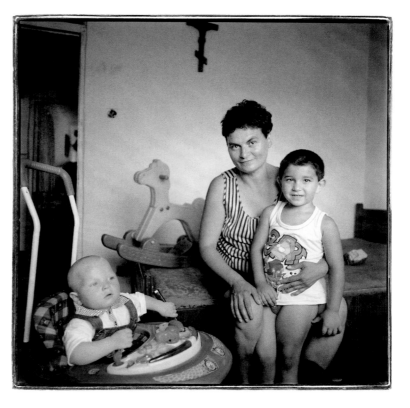

LIVIU REBREANU, 2003

BISTRITA, 2002

(OPPOSITE LEFT) BECLEAN, 2002

(OPPOSITE RIGHT) HERINA, 2003

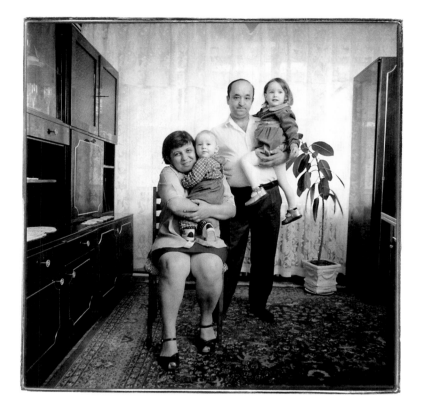

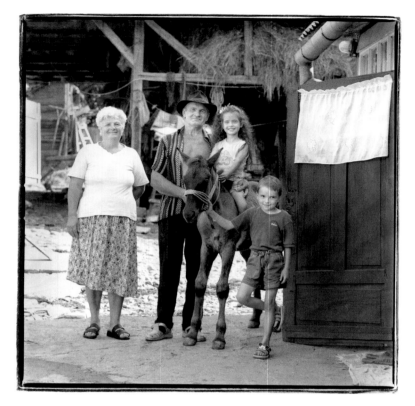

BISTRITA, 2003

GHINDA, 2002

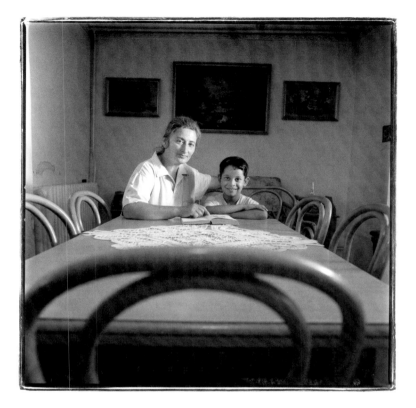

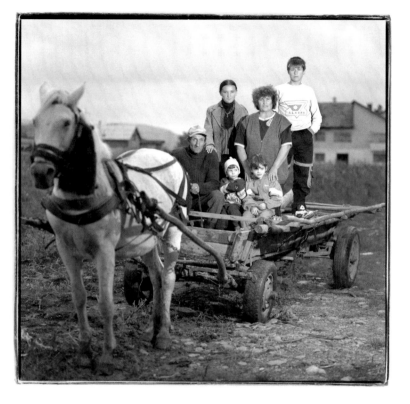

BECLEAN, 2002

VIISOARA, 2003

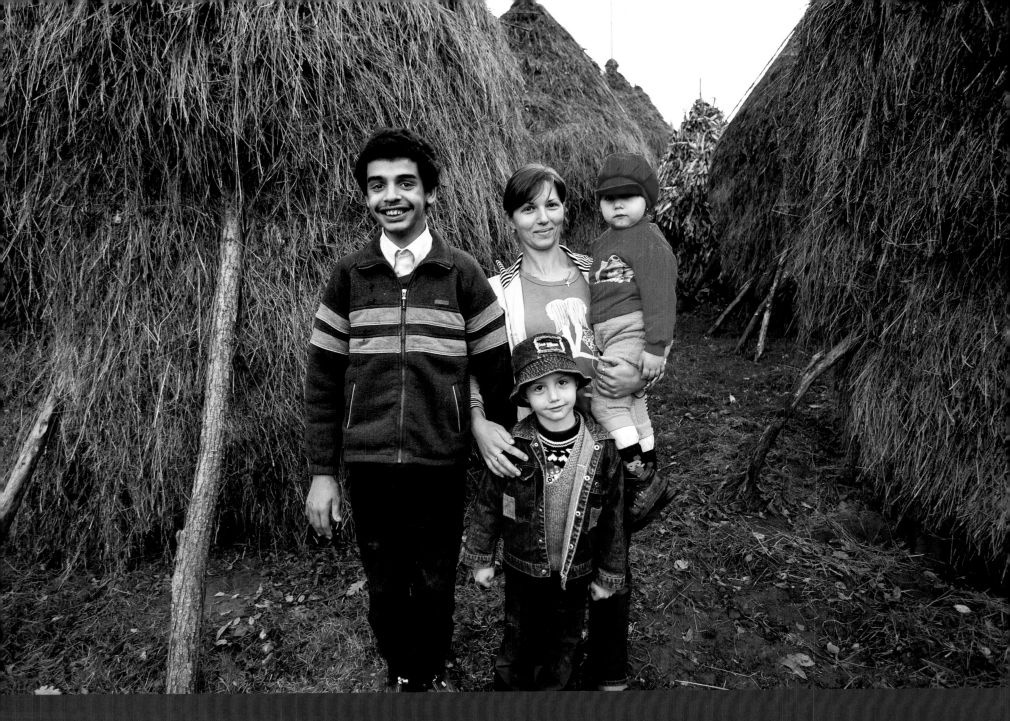

OVIDIU, MARIA, MARIUS, AND ANGELA, AT HOME NEAR REBRISOARA, 2004

7. A Bridge to Somewhere

THE ARRIVAL of a handicapped child—what we now prefer to call a special needs child—at a private home is akin to introducing a black hole of time and energy into the life of the family in that home. That is why I have always admired Maria Eremi, one of our most loyal foster parents over the years. She has been steadfast, compassionate, and good-humored in her care of children with disabilities, treating them with the affection and respect she accords her own biological son, Marius, and daughter, Angela, who were ages three and one, respectively, when her first foster child came to live with the family in 2004.

Visits to Maria's remote homestead represent an arduous journey, but I have always been glad for the chance to make the trip. She and her extended family live about five miles north of the Transylvanian town of Nasaud, or about an hour's drive from Bistrita. There are always two or three of us along for the ride, and time passes quickly as we discuss the latest successes or stumbling blocks in the programs launched by Fundatia Inocenti, the in-country version of

RCR. We finish the drive by parking our foundation's car (donated by Mercer Island Rotary Club in Washington State) at a pullover area alongside an obscure rural lane, and our trip continues on foot.

There's a long, tortuous walk down a steep, wooded hill, and then we cross a set of railroad tracks to reach what I called, when I saw it for the first time, the Indiana Jones Bridge to Nowhere. That is how dangerous it looked. It's a 150-foot-long rope bridge with wood planks for a walkway, spanning the rocky streambed of the Somes River some thirty feet below. It is in fact a strong, perfectly safe footbridge, but a winter crossing on its icy surface requires great caution. It is definitely a seasonal carrier. Once I got to the bridge to find it lined with dozens and dozens of wooly sheepskins hung out to dry.

After crossing the bridge, visitors walk along a shallow stream for another half mile or so. Boots are advisable for this trek, even though in the wet season they'll become heavy with caked mud. Pedestrians must usually negotiate a passage around a cow or two on the way, as the animals

drink from the mountain runoff that supplies the stream with clean, cold water. One also encounters the occasional horse-drawn cart rolling along the same bumpy route on rubber-tired wheels.

Maria lives in a small house at the edge of a compound of similar dwellings, barn buildings, chicken coops, sheds, stables, pastures, and animal pens. Several generations of one family occupy the compound. Maria's husband, Dumitru Eremi, works for the county as caretaker of a water reservoir and dam at some distance from the enclave, so he usually comes home only on weekends. His grandfather, Leon Sangeorzan, the patriarch of the clan, is responsible for the major decisions affecting life in the compound.

Although some residents, like Dumitru, work away from home, most spend all their time in the immediate area. Staples like flour, sugar, and coffee are purchased in the nearest town, Rebrisoara, two miles away, where Maria grew up. But the people in the enclave are largely self-sufficient, growing their own vegetables and fruits (including red and white grapes for making wine, plums for making *tsuica*), producing milk and eggs from their cows and hens, and raising pigs, rabbits, turkeys, chickens, and quail for meat. Horses are used for plowing, cultivating, and transporting. Goats and sheep provide meat, milk for making cheese, and wool.

Then there are the junkyard dogs, which are everywhere. They are not so much pets as protection, especially for the farm animals, from wolves, wild boars, and bears. (Romania has the largest black bear population in Europe.) One winter night, when it was too late for a group of visitors to walk the stream back to the Indiana Jones bridge, Leon took us in pitch-black darkness, without a flashlight, on a circuitous but safe alternate route through a maze of backyards and barns. He knew every dog by name and placated each of them so we could pass each habitation in the compound and reach the bridge.

On my visits to Maria and her family, I would often run into people so distinctive that they cried out to be photographed. Actually, wherever I went in Romania there were photo opportunities, and with them the chance to interact with people. For example, I once took a picture of a woman and her cow, and on my next trip presented her with an enlarged print. She was so pleased she gave me a bottle of homemade *tsuica*, corked and wrapped in tartan-plaid cloth. Another time, I approached an older couple in a field as they worked at a towering haystack with long-handled pitchforks. After I took their picture, Maria, who had followed us down, told me they were the grandparents of one of her cousins. It's not a Romanian proverb but it probably should be: It takes a village to give directions.

A visit to a home in Romania, even if it is largely a business visit, is never short. The rules of Romanian hospitality call for food, drink, and time. From a professional point of view, looking in on Maria to see how she and her children were doing was probably a task that could be completed in an hour, but we always spent at least two or three hours with her. Maria carefully dressed up for our visits and always served refreshments. The modestly furnished house, without indoor plumbing, is clean as a whistle. Maria has a cell phone and a color TV. Her favorite programs are the news and a variety show called *Cireasa de pe tort* (Cherry on the Cake). She's learned a smattering of English from television and is clearly pleased when she can use one of her English words in conversation.

Tiberiu "Tibi" Hunyadi, our outreach worker coordinator and head of our group home in Nasaud, usually joins me on these visits, as does Maria Ott, an outreach worker in her forties who happens to have wonderful instincts about people—a decided asset in doing her job. When Liz Callahan, an expert on corporate social responsibility, made her first trip to Romania, one of the side journeys she made with Mrs. Ott and me was to Maria's house. Liz was in the country to participate in a conference on her specialty, sponsored by RCR and the Bistrita-Nasaud Chamber of Commerce. Later she would call her side trip "the most magical part" of her time in the country. But as we neared the end of our drive, Liz was feeling tired and perhaps a little nervous about the forthcoming meeting with Maria. Without any words exchanged, Mrs. Ott sprang into action, reaching from her seat in the back to massage Liz's neck and shoulders until her tension melted away.

Working out of her home in Nasaud, Maria Ott is responsible for eight foster children in the area. Typically, she makes two three-hour visits a week to each foster home, but Maria Eremei's house is so remote, Mrs. Ott gets there only two or three times per month. Her routine varies with the needs and demands of each foster child, but typically she reviews how things are going for the child with the foster mother and discusses possible solutions for any problems within the family that may have cropped up. She takes them games, puzzles, and books. She guides the children in coloring and painting activities and in modeling with plasticine (similar to our Play-Doh).

Our outreach workers may be mature adults or young people. Sometimes it's advantageous for us to have an older woman on the job. With her own experience as a mother and her deeply ingrained rural values, Mrs. Ott can easily relate to Maria's life situation. All our foster parents need outreach and communication on a regular basis. When a parent is isolated in a rural setting, as Maria is, this contact can be even more important to the child's welfare and the foster parent's confidence.

Foster parents receive approximately $90 a month from the government in return for taking care of a child, a significant sum for families of limited means, and there's no question that money is a motivating factor in a family's decision to take in a youngster. The money certainly helps Maria and her family make ends meet. The trick in finding good foster homes, of course, is making sure that money is not the sole motive for joining the program. For Maria, foster-parenting offered the chance to work at home and do something she loves—take care of kids.

Maria's first foster child was Ovidiu Cheresi, who came into her home in October of 2004. An intellectually impaired boy, he had been living in the Nasaud Camin Spital, a hospital for handcapped children and adults that offered little if any social, therapeutic, or educational care—a warehouse for the unwanted. Thanks to Marie's patient care and her own children's acceptance of Ovidiu in spite of his severe cognitive deficiencies, Ovidiu was able to fit into the life of the house in a matter of months. He was given jobs to do on the farm, easy tasks that made him feel useful. He became especially fond of the cows that were placed under his care.

Ovidiu stayed with Maria until he reached the age of eighteen, when by law all foster care is "timed out." But he remains in the area and in touch with Maria's family, thanks to the decision by one of Maria's cousins in a nearby village to adopt the teenager.

With Ovidiu settled in Maria's cousin's home, Maria took in a new foster child, five-year-old Andre Costra, in June of 2006. Andre, who suffered from an eating disorder and behavioral issues, had not thrived in two earlier placements in city apartments. Tibi thought he might do better in a quiet rural setting, and time has proved him right.

Disorders related to food are common in children who have been abandoned in orphanages. Used to nothing but soft food, they hesitate to take items they have to chew. Or they hoard their food out of insecurity about getting more to eat. In one case, a girl took her chicken dinner to bed with her instead of eating it.

As Andre became more comfortable in his new home, Maria gradually introduced meat and fruits and vegetables that required chewing into his diet, and within a year he began to eat normally.

Although Maria has not had much formal education, she is very bright, worldly and yet grounded in her rural life. She accepts new ideas, for example concepts of child development that can bewilder her older counterparts. She represents the next generation of peasants, those who have had no experience of living under communism. Perhaps she and others like her will lead the country away from the communist past and into a more hopeful future, where there's a cherry on every cake.

STEPHAN AND FLORIN (HE WAS IN A CAMIN SPITAL WITH OVIDIU) ON BRIDGE OVER SOMESUL MARE RIVER, 2004

(FAR RIGHT TOP) FOSTER CHILD ANDRE AT HOME, 2008

(FAR RIGHT BOTTOM) MARIA WITH HER DAUGHTER, ANGELA, 2007

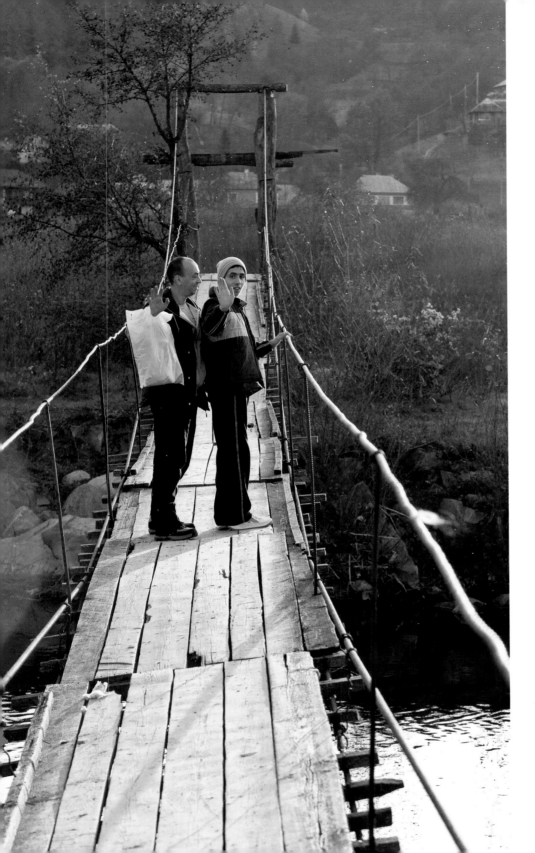

TWIN GIRLS IN FOSTER CARE, BECLEAN, 2002

DOWN SYNDROME CHILD WITH FOSTER GRANDMOTHER,
NIMIGEA DE JOS, 2005

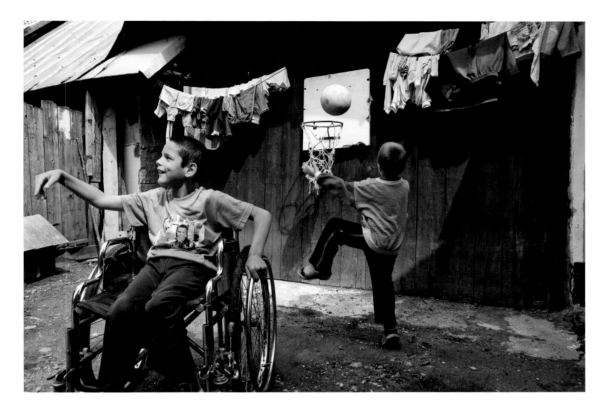

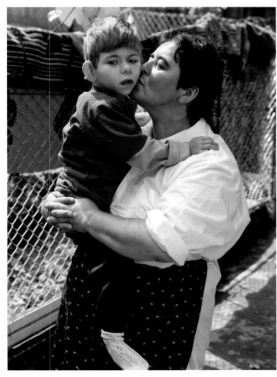

(TOP) SPORTS BRING TOGETHER HANDICAPPED BOY AND FOSTER BROTHER, NIMIGEA DE JOS, 2003

(BOTTOM LEFT) FOSTER CHILD WITH SERIOUS ILLNESS GETS LOVING CARE, NIMIGEA DE SUS, 2004

(BOTTOM RIGHT) FOSTER CHILD WITH ATTITUDE, BECLEAN, 2003

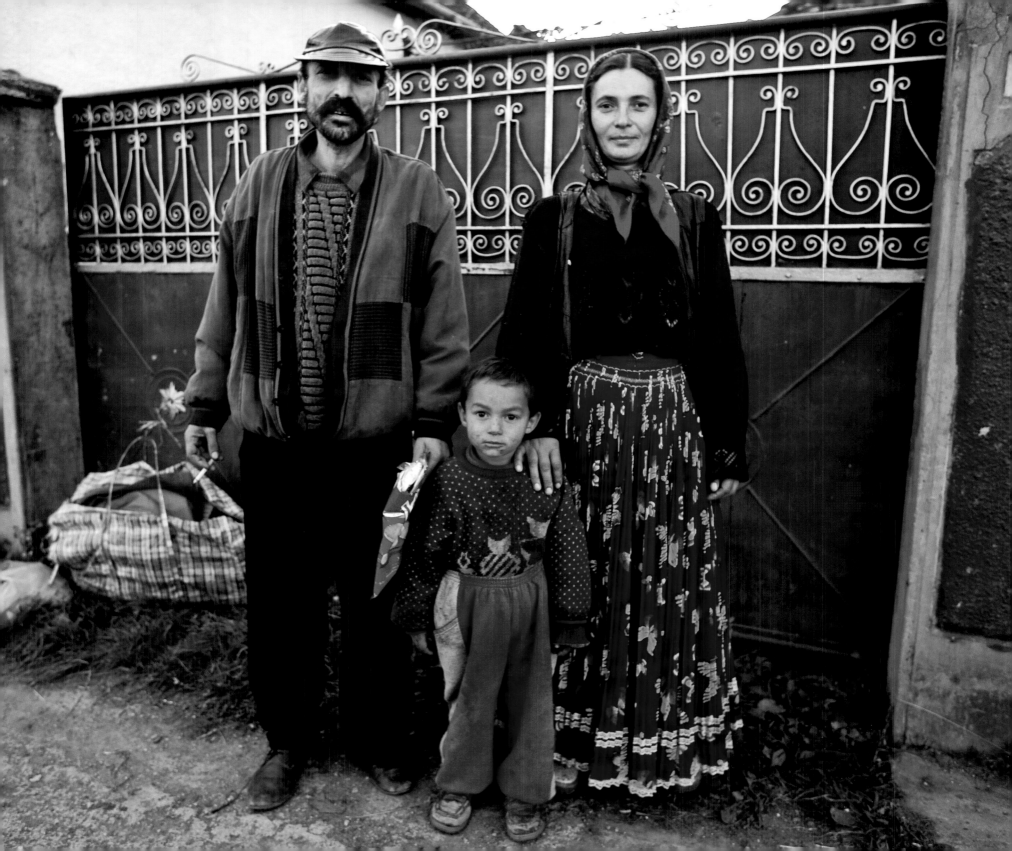

8. Gypsies and Strawberry Orphans

A UNICEF STUDY of child abandonment in Romania in 2003 and 2004, released in March of 2005, revealed that the family practices, or more precisely family malpractices, that came into being during the Ceaușescu era continued to inflict suffering on the country's youngest children.

In each of those years, the study showed, some four thousand newborns were abandoned in maternity wards, and more than five thousand were abandoned in pediatric hospitals and recovery wards. Over 60 percent of the mothers came from rural areas. Most of the women who intended to abandon their babies delivered them in maternity wards located in large cities—in order to cover their tracks more easily.

Although Gypsies, or Roma, make up only 10 percent of the general population, 60 percent of the mothers who abandoned their children, in maternity or pediatric wards, were of Roma ethnic origin.

With its total population of 21.6 million, Romania is the second-largest country (after Poland) in Eastern Europe. It also has the largest population of Roma within its borders.

According to the nation's official census, there are 535,000 Gypsies living in the country, but many observers believe this number is far short of reality. Unofficial estimates place the Roma population at anywhere between 1.8 million and 2.5 million.

There are approximately 12 million Gypsies worldwide, most of them in Europe, and wherever they go, trouble seems to follow. To Europeans they are the "other," nomadic people of dark complexion who speak a foreign language similar to several ancient Indian tongues and who harbor superstitions and beliefs incomprehensible and even repugnant to those of the general population.

The Roma are believed to have originated in south Asia, migrating into Armenia and Persia in the tenth century and spreading from there into the Balkans in what amounts even today to a perpetual diaspora. They were originally called Gypsies in the belief that they had in fact come from Egypt. Traditionally, Gypsies have earned their keep as musicians, blacksmiths, coppersmiths, tinsmiths, horse traders, gold panners, and basket makers. Today, evolving with the times,

they are more likely to trade in used cars than in horses.

Mainstream citizenries throughout Europe regard the Roma with deep suspicion and disdain. The stereotypical Gypsy is a thief, pickpocket, con man, scam artist, and someone who will cut off his own child's hand to make that child a more profitable beggar (hence the term "stump children"). Madonna was practically booed off the stage during a concert she gave in Bucharest in the summer of 2009 when she challenged this stereotype. Some sixty thousand fans had gathered in a downtown park adjacent to Ceauşescu's "People's Palace" for the event. But when, following a performance by Gypsy musicians, the pop star spoke out against discrimination directed at "the Romani people," the crowd reacted angrily. (In the aftermath, some pundits decided the crowd thought Madonna had confused the Roma with the Romanians, thus adding injury to insult.)

Gypsies were persecuted by the Nazis during World War II—hundreds of thousands died in concentration camps—but they fared better under communist regimes like that of Ceauşescu. Nevertheless, Europe witnessed an increase in hate crimes against them following the 1989 revolutions. In a Transylvanian village in 1993, two Gypsy brothers were clubbed to death and fourteen Gypsy homes were burned to the ground following the knifing murder of a Romanian by a Roma. Since then more than thirty attacks on Gypsy settlements have been reported in the country, and the violence has spread to Hungary, Bulgaria, and the Czech Republic.

The European Union, to which Romania gained admission in 2007, has issued warnings to the Romanian government regarding protection of the rights of minorities, especially the beleaguered Roma. Still, people's instinctive wariness of the Gypsy is not likely to go away soon.

In social terms, the Roma pose enormous problems for the Romanian government at the national, regional, and local level. Like Gypsies everywhere, the Roma of Romania refuse to be assimilated into the general culture. Deploring conventional education—there is no word in the Roma language for "read" or "write"—most Roma families keep their children out of school.

I made friends with a teacher in a grade school serving a largely Gypsy population in a village near Bistrita, and I have visited her classroom several times. Twenty-seven children are assigned to her class, but only five or six kids show up to learn on a regular basis. One who does make the effort to attend class every day is a Roma girl named Deanna who, thanks to her teacher's encouragement, has become very interested in her studies. In fact, Deanna wants to be a teacher some day, a remarkable ambition considering her family situation. She lives with her grandmother because her mother was killed by her father several years ago.

Deanna is smart, well behaved and beautiful, and she has the confidence in herself that would normally ensure educational success. Her grandmother has been supportive, but her teacher worries that some of her male relatives will interfere with the child's ambitions, and that as Deanna moves into middle school from grade school "it will be the dangerous period for her."

Roma familes figure in a pilot program we have launched in Bucharest, designed to help mothers keep their babies rather than abandoning them. The plan is to identify women in maternity wards who seem likely to give up their babies for economic or family reasons, then provide them with regular support through home visits by a team consisting

of a social worker, a psychologist, and a nurse. This team would help the mothers avail themselves of social services and acquaint them with personal care and hygiene issues affecting both mother and child. Simply informing them of problems such as shaken-baby syndrome might well prevent the problem from ever occurring.

Early stages of the program revealed a disproportionate number of young Roma mothers who are vulnerable to child abandonment.

Membership in the EU has had and will continue to have repercussions in Romania, some of which are quite detrimental to young children. The main problem is that millions of Romanians, most them from rural areas, have migrated to relatively lucrative jobs in Western Europe, leaving their children in the care of grandparents or other relatives not necessarily equipped to rear young children.

According to a February 15, 2009, report in the *New York Times*, "Romanians became the strawberry pickers, construction workers and housecleaners of choice, doing the jobs that workers in richer neighboring countries no longer wanted." The article pointed out that a Romanian woman working as a house cleaner in Rome could earn over $700 a month, three times her income in her homeland.

Research by the Soros Foundation has established the fact that some 170,000 children have one or both parents working in such jobs abroad, creating a generation of what one sociologist calls "strawberry orphans." In some cases, feelings of abandonment and depression among these children have led to suicide. The malaise is especially apparent in cases where the mother leaves Romania to seek work.

"It is the mother who cares for the children in Romania," observes psychologist Denisa Ionescu, who works with the offspring of migrants. "So when the mother leaves, the child's world falls apart."

The global recession was not likely to improve matters, according to Fundatia Inocenti director Marin Mic. "The unemployment rate will get higher and higher as Romanians who have lost their jobs in Spain and Italy and other EU countries return home," he says. "The steep decline in the Romanian lei against the euro has forced the government to place a freeze on hiring, which prevents local governments from hiring social workers and new foster parents, who are considered government workers. Without foster parents, we can't find homes for abandoned children."

Romania has been occupied by foreign rulers for sixteen centuries, hence one of its most venerable proverbs: "A change of rulers is the joy of fools."

Membership in the European Union has brought challenges and opportunities, but Romanians have never considered the EU a panacea. Like Romania, Romanian Children's Relief and Fundatia Inocenti have learned to remain clear-eyed and to roll with the punches.

As Bill Clinton used to say, "It's the economy, stupid."

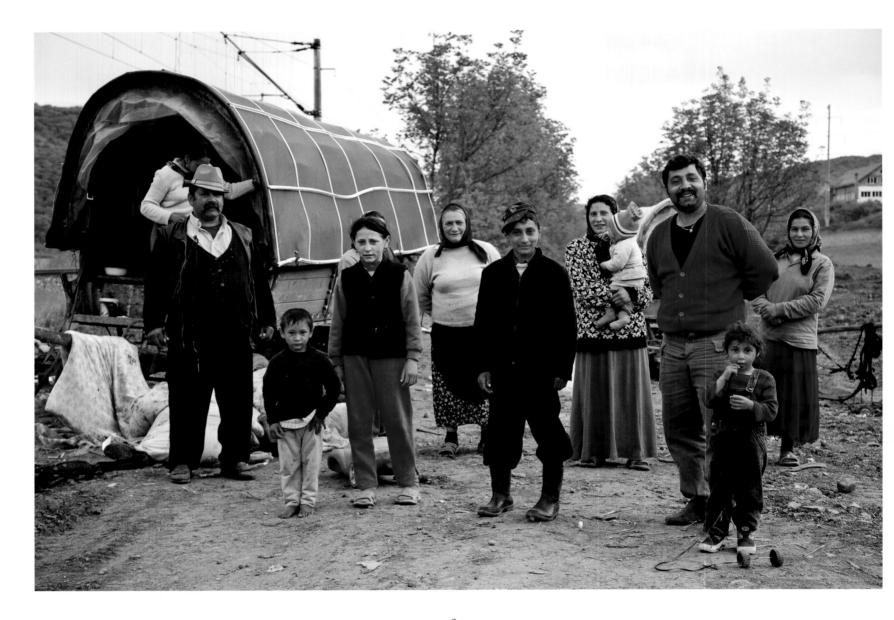

EXTENDED ROMA FAMILY TRAVELING IN TRANSYLVANIA, SARATEL, 2008

(TOP) A ROMA FAMILY'S MAKESHIFT QUARTERS FOLLOWING FLOOD, TAGU, 2008

(BOTTOM) ROMA GIRL IN LITERACY PROGRAM, BISTRITA, 2009

(TOP) ROMA DISTRICT INSIDE OLD CITY, BISTRITA, 2009

(BOTTOM) ROMA CHILDREN HARVESTING GRASS TO FEED FAMILY PIG, TAGU, 2008

INTERIOR COURTYARD, ROMA QUARTERS, BISTRITA, 2009

ROMA GIRLS, BUCHAREST, 1995

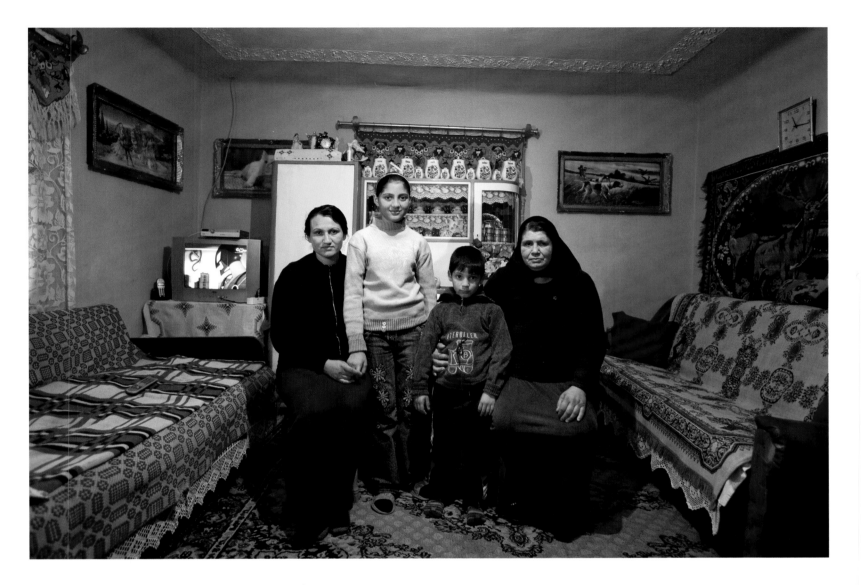

DIANA AND FAMILY AT HOME, RETEAGUE, 2008

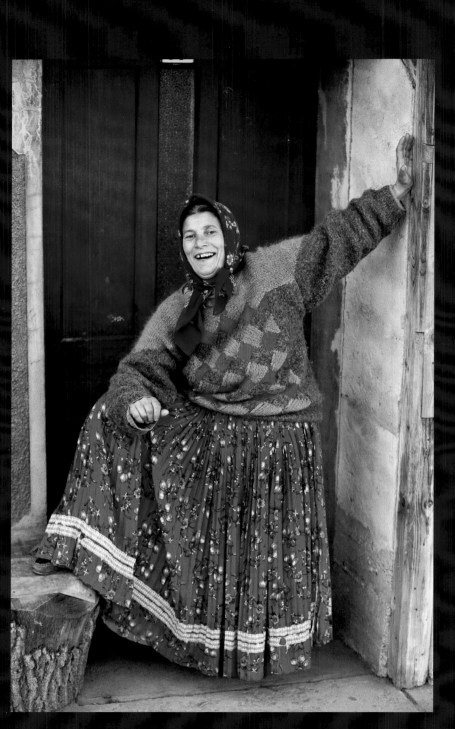

ROMA WOMAN, GORNESTI, 2005

(OPPOSITE RIGHT) ROMA
VILLAGE ALONG HIGHWAY,
TRANSYLVANIA, 2006

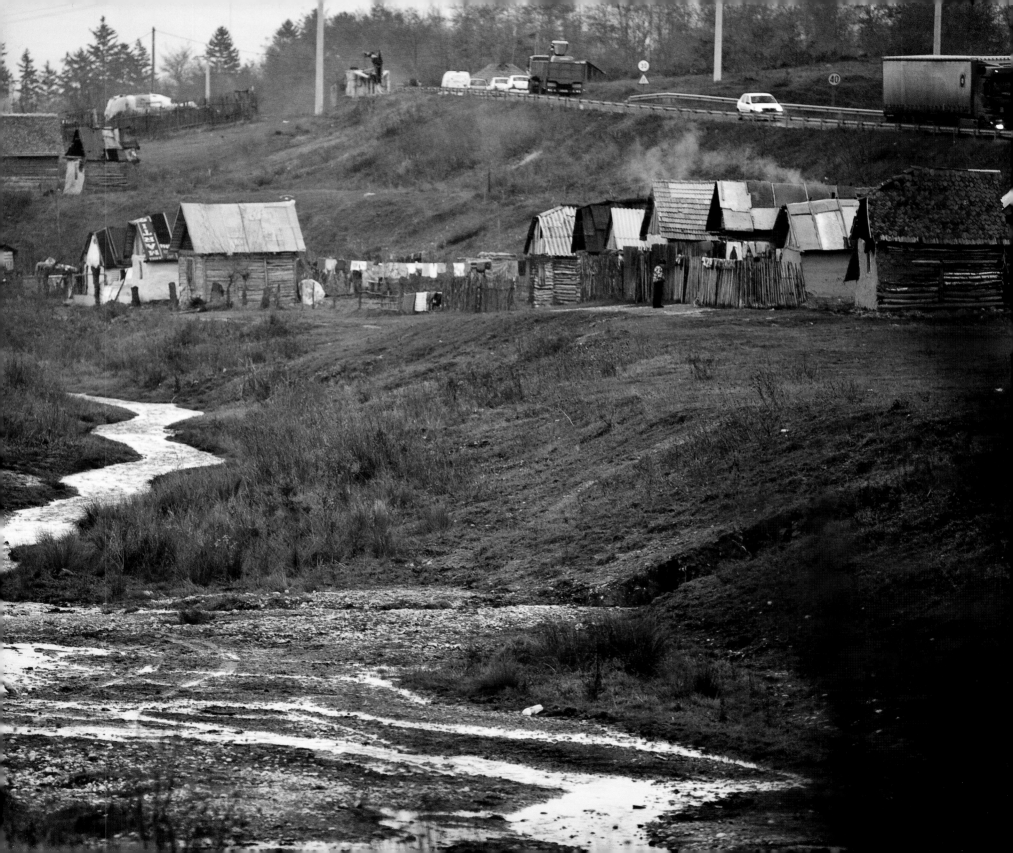

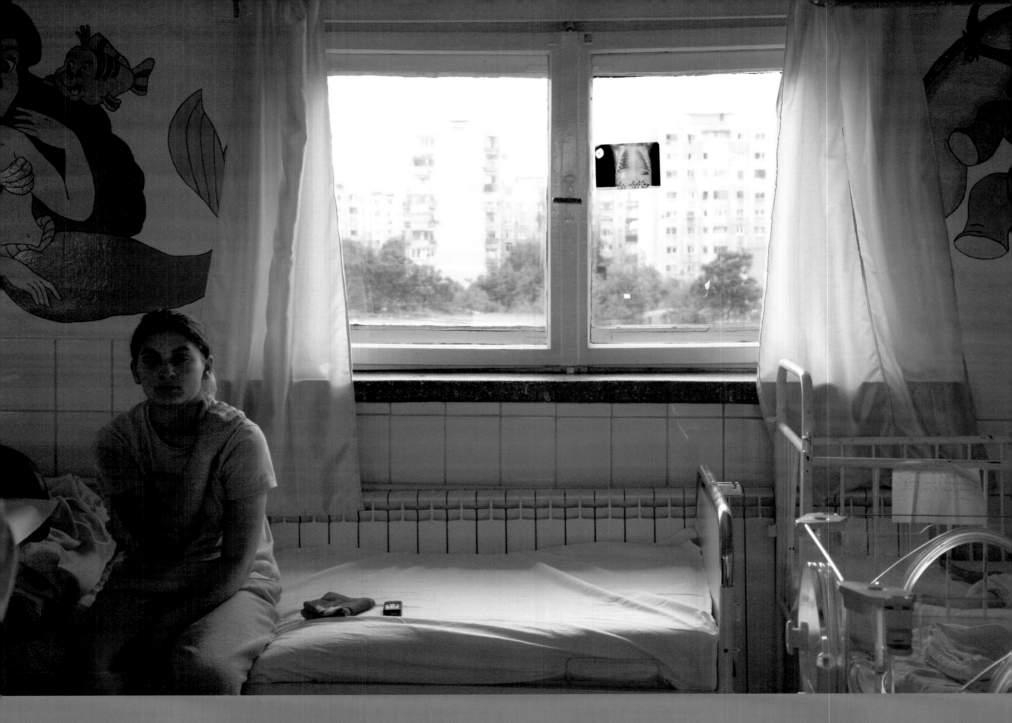

PEDIATRIC INTENSIVE CARE UNIT, DR. ALFRED RUSESCU HOSPITAL, BUCHAREST, 2009

9. Back to the Future

I REMEMBER ION, a five-year-old boy suffering from autism, whom we placed in a foster home in a village outside Nasaud. The foster mother was a peasant woman with little education and no formal knowledge of child psychology. Nevertheless, she did her best to lure the child out from behind his veil of silence. But nothing seemed to work.

The woman faithfully attended Mass every Sunday in her village church, and she decided she might as well take along little Ion. Almost immediately, she noticed that the chants of the priest during the service aroused the boy's interest. After weeks of attending church, the child started to sing, mimicking the words he heard in the chants. And then he began to speak.

By the third time I stopped by this home, little more than a year after my first visit, Ion knew eleven words, and he used them proudly to communicate his needs and wants.

Valentina Maghirescu directs our program at Rusescu Hospital in Bucharest. Vali spent four years in the United States, obtaining a degree in psychological counseling at Cambridge College in Massachusetts, before returning to Romania to take up her present post.

"One example of successfully keeping a child in the parental home involved a baby named Georgiana," Vali relates. "The little girl was born with a severe heart defect that required surgery, which took place at another hospital in Targu Mures."

Following the surgery, Georgiana returned to Rusescu Hospital to convalesce. "Working with her doctors," says Vali, "the staff of Fundatia Inocenti developed an intervention plan for her that called for five hours of play and psychomotor stimulation per day."

Day by day, Georgiana progressed from being a very sick baby to a healthy toddler. "In the year and a half we tended to her, Georgiana became a favorite of our staff," says Vali. "Her face would light up when we came to her hospital bed and took her to our Child Life playroom. She went from drinking from the bottle to eating with a spoon. She began to walk and say her first words. All these exciting moments in her development happened in our playroom."

A significant part of the intervention involved keeping Georgiana's parents in the picture. Her family lived in a small village about fifty miles from Bucharest, and they could not afford to make frequent visits. Also, they had three other children to care for.

"But they came to the hospital when they could," says Vali, "and we could see that they remained very much attached to their child. As Georgiana's condition continued to improve, we made arrangements—thanks to a generous financial donation from one of our volunteers—for the parents to visit with the child every Friday."

Finally, Fundatia Inocenti arranged to send Georgiana home.

"The family lived in their village in very modest circumstances," Vali recalls, "but when we arrived, her two brothers and one sister were waiting for her, and within minutes they began playing together as though they had never been apart."

The homecoming occurred in August of 2008. Vali and her staff have looked in on the family since then, and they accompany Georgiana whenever she has follow-up appointments with cardiologists, "but we don't want to overdo our presence," she notes. "With good parents, the idea is to let them do the parenting, and not make them dependent on us long term."

Our physical therapist in Bistrita, the energetic and highly committed Razvan Chirlejan, oversaw a dramatic intervention involving a girl named Roxana. In 2005, when Roxana was eleven, she was hit by a speeding car after getting off her school bus and suffered multiple injuries—her body was thrown seventy-five feet through the air. The girl was in a coma for three weeks, and when she finally came home she remained virtually paralyzed. Doctors had told the family she was unlikely ever to walk again.

"Her father came to us for help," Razvan recalls. "He had read about Fundatia Inocenti in the local paper. Most of our interventions are with much younger children with severe disabilities—babies with cerebral palsy, for example. But I agreed to come to see the girl."

When he visited Roxana at home, Razvan found a child who could hardly move. But he stopped by almost daily for six months, first manipulating her arms and legs with passive exercises, then gradually getting her to move her limbs herself. Soon he had her sitting up in bed, and finally, after another four months, standing up on her own.

"It was a huge accomplishment for everybody—for her, for her parents, for me," says Razvan. "And in a few more weeks, she took her first steps."

Progress continued as Razvan began to work with Roxana at our rehabilitation center. When he took her to an appointment at a medical clinic where she had received treatment, the attending physician was stunned by her progress. In another year's time, Roxana was ready to go back to school.

Here the story becomes more complicated.

"There were lots of problems," Razvan reports. "She had been an excellent student, but the injuries to her head had affected her cognitive skills—and given her almost constant headaches. Learning new subjects now came hard to her. She retained some paralysis on one side, so her walking gait was not normal. And she had gained a lot of weight from the drugs she took to control her pain. So some of the other pupils made fun of her for all these problems."

Like many teenagers with no health issues, Roxana has become harder to deal with, less cooperative than she was

at the beginning of her therapy. Yet Razvan is determined to carry on with his program to help her cope with her handicaps.

I think of incidents like this—breakthroughs in human development, cherished all the more for being unexpected—as mini-miracles, charms to add to the charm bracelet of my memories of Romania.

None of the breakthroughs and advances we've made in Romania could have happened without the inspiration and dedication of the people on the ground in Bucharest, Bistrita, and other locations—the hundreds upon hundreds of staff workers, educators, physicians, child psychologists, therapists, and other specialists, the volunteers of all ages who minister to children in playrooms in hospitals and orphanages and in foster homes and group homes, and the foster parents who have opened their homes and hearts to children in need. Other aid groups and service organizations, as well as private companies large and small, have come on board not only as new sources of funding for our activities, but as the friends and champions of our cause in local communities.

This organization that was "made in America" at the onset has evolved into an NGO that is largely of the Romanian people, for the Romanian people, and by the Romanian people. And as we have become more deeply entrenched in the culture and society of the country, we have grown and adapted to meet the changing needs and conditions of Romania's abandoned children.

Our Child Life program, which started in Rusescu Hospital in Bucharest in 1991 and which has grown to serve some six hundred children and four hundred mothers annually, was instituted in Bistrita County Hospital in 1999.

The Me & My Family program, designed to assist children moving from institutional care into foster care and group homes, got its start in an orphanage in Bistrita in 2000. Four years later it was expanded to give the same kind of assistance to special needs children.

Our early literacy program got off the ground in 2002 in both Bucharest and Bistrita with weekly home visits by sixty volunteers armed with books, and by the following year was introducing storytelling to young patients in hospitals in both cities.

"The most important thing about having a reading session with a child," says Bianca Filip, who directs the literacy volunteers in Bistrita, "is to make it fun, not work, so the atmosphere during the session is relaxing and enjoyable for the child."

Bright, bold picture books are used to make it easy for the child to focus and to identify things. Books with just a few words can make early learners more confident about reading. In stories with characters in them, volunteers use different voices to depict each character. Kids are encouraged to ask questions about the stories and the characters.

Writing exercises are also included in each session, even if they are as simple as having a child print his or her name on a drawing. Making little books is always fun, and it helps develop the child's creativity and self-expression.

"On home visits, we always try to involve the parent or foster parent in the literacy process," says Bianca. "We remind them they are the first and best teachers the children will ever have, and the more they themselves encourage reading and writing in the home, the more the children will flourish."

One of Bianca's most satisfying experiences has been

watching the volunteers work with the children in our placement center in Beclean. "Most of these children were physically and emotionally abused in their families," she relates, "so it is heartening to see them relate to a 'special friend' in the form of a reading volunteer. In just a year's time I have seen many of these children grow more secure and feel more self-esteem and just be much more interested in reading and writing, and these skills will serve them well when they start school."

In our second decade we expanded on several new fronts in an effort to help kids with handicaps and disabilities. A child sponsorship program was begun to help older special needs youths in foster or group homes. An early intervention program was launched in Bistrita, complete with a recuperative center; the program sends teams of therapists on rounds of home visits to identify developmental delays in young children and to mitigate the problems via intensive therapy. We opened day centers in two outlying towns in Bistrita County for children with multiple handicaps.

Earlier I mentioned the Olympics of the Innocent, a one-day sports-and-arts event that was such a hit when we started it in Bistrita in 2007 that we have made it an annual event. Other celebrations are now on our calendar every year, including the International Children's Day party, held on June 1, a St. Nicolas charity gala for special needs kids in early December, and Christmas parties in both Bucharest and Bistrita, when we hand out gifts to hundreds of children in foster care and in hospitals.

These special events would be all but impossible to pull off if it were not for volunteers—local people who believe in our work and want to help us succeed. We need experts and administrators, but volunteers are at the heart of any

humanitarian program. In this regard, we have been especially fortunate.

A teenage girl named Adriana Stejerean, who was named our volunteer of the year in Bistrita, summed up her work as a literacy volunteer as follows: "My experience has helped me improve my understanding of children with disabilities, and of life. I feel I am doing something that makes me feel good, something that is useful for the children, and something that helps me develop as a human being."

Beth Orshalimy, one of our most experienced and valued volunteers, who comes in several times a week to lend a hand in Rusescu Hospital in Bucharest, reflected on her own time in the program: "When the babies are brought into one of the playrooms the first time, they are overwhelmed by the sensory stimulation of colors, music, laughter, and the general happy environment. By the second or third time, they know what to expect and in no time at all, they are playing with their favorite toys, getting a soothing massage, or being spoon-fed tasty baby food."

Our volunteers get it—it's all about the kids.

When Vali, our Fundatia Inocenti director in Bucharest, came back to Romania from her schooling in America, she admits her expectations for social and economic progress in her homeland may have been too high. "I'm a natural optimist, and I thought change would come more quickly in our society," she says. "Sometimes I think we're still in a kind of post-communist funk, still making excuses instead of looking for solutions, pointing out blame instead of giving encouragement. All those years spent without responsibility for taking care of ourselves have had an effect.

"Yet," Vali continues more hopefully, "I see so many young people getting more involved in helping their com-

munities. And that's one reason I came back home. It is our job and duty to help both the older and younger generations to adapt to a new and more proactive lifestyle. And that is behind the success of our programs—the willingness of others to give of their time and money to build a new and better Romania."

RCR has grown from one staff position and a budget of $11,000 in 1993 to a staff of twenty-two and a budget of $300,000 in 2010. The number of children we serve has grown from thirty to close to a thousand. As I mentioned earlier, we have increasingly stressed the importance of hands-on help from Romanian professional and volunteer caregivers, but we still rely on help from the United States. Volunteering their time in support of our efforts, both in the U.S. and in Romania, are American doctors, physiologists, occupational therapists, physical therapists, special needs educators, and reading specialists representing various U.S. universities and hospitals.

I could never have predicted such an outcome as a result of the publication of a few black-and-white photographs in 1990. One of our supporters, a Massachusetts woman, has sent RCR a check for $40 every month for the past twenty years. Multiply her gesture by a factor of thousands. There's no way I can adequately express my admiration and respect for such selfless generosity.

People sometimes ask me, "Why Romania? Why not help the kids here in America?" My only reply is that a chance opportunity came along to make a difference, and we took it. We heeded the call of an orphanage director in Bucharest at a time when her country was emerging from its long nightmare, when she asked, "Who will take and love Ceaușescu's children?"

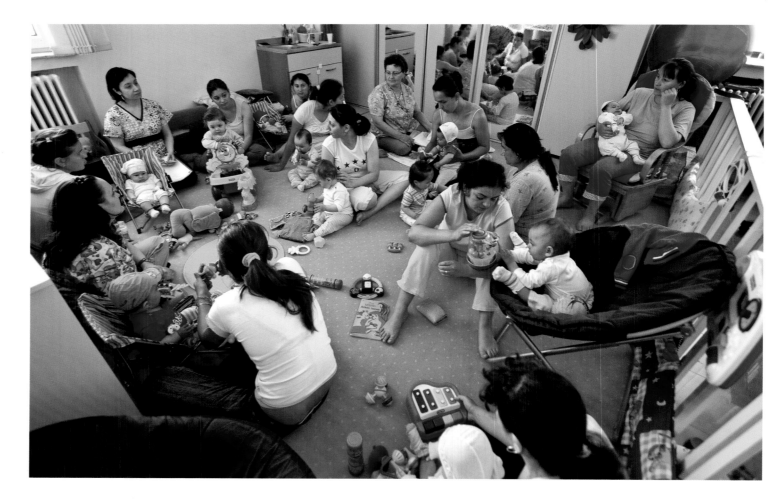

The Face of RCR Today

WHEN I'M IN ROMANIA, I never attend a Romanian Children's Relief meeting, or visit a hospital, school, or placement center where RCR provides services, without a camera around my neck. The pictures on this and the following pages were taken by me in recent years and show our staff and volunteers doing what they do best—bringing life and light to infants and children who otherwise would grow up neglected and without hope. Our strategy has been to develop community-based pro-brams that meet the ever-changing needs of the children we serve.

It is especially gratifying to see Romanians pitching in to help us help children. One of our staff in Bucharest put it best: "It is our job and duty to help both the older and younger generations to adapt to a new and more proactive lifestyle. And that is behind the success of our programs—the willingness of others to give of their time and money to build a new and better Romania."

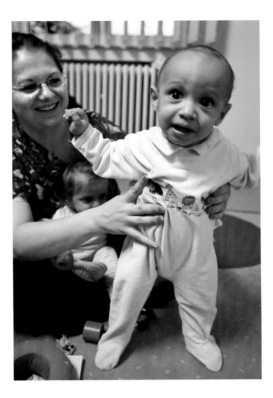

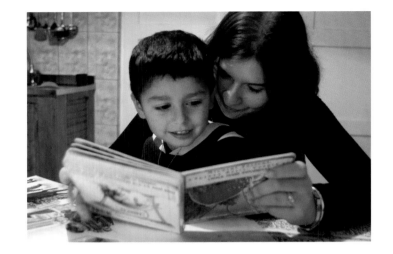
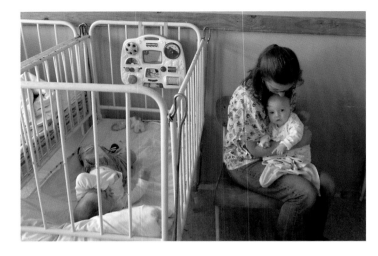
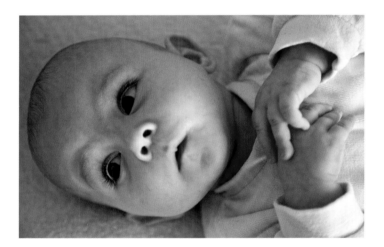
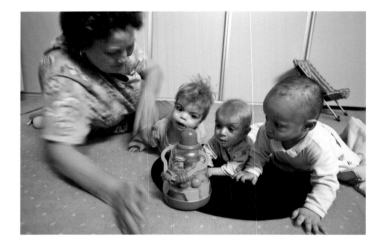

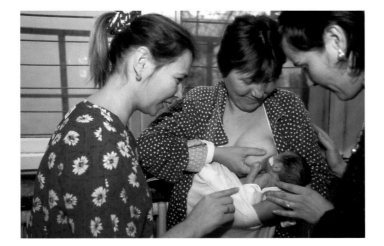

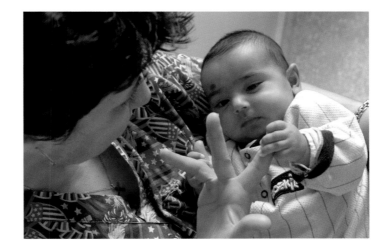

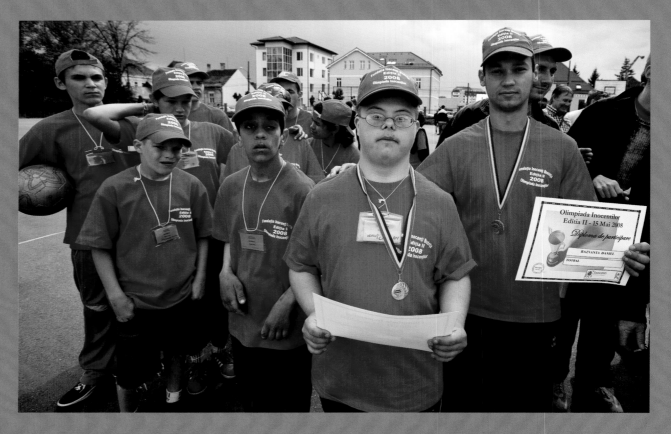

Going for
the Gold

PERHAPS THE MOST popular community event we sponsor is the Olympics of the Innocent, a lively one-day series of competitions for special needs children in the city of Bistrita. It is modeled after the Special Olympics, only art, music, and dance are included in the activities along with sporting contests. I love putting my camera to work on this day because the kids put their hearts and souls into the races they run, the balls they kick, and the songs they sing, and their expressions reflect the excitement and exhilaration they feel. Many of the "Olympic" events take place in and around Bistrita's central square. The first year the program was held, some of the merchants on the square were worried the hubbub would drive away business. Now shops and cafes bordering the square set out extra chairs for the many hundreds of spectators drawn to the event. All special needs kids in the area, and not just those who are being served by Romanian Children's Relief and our in-country Fundatia Inocenti, are welcome to participate in the games, and this has gained us gratitude and support from local people we might not have otherwise reached.

It's a gold medal day for everyone.

My Romania

(ABOVE RIGHT) ROADSIDE SHRINE, BLAJENII DE JOS, 2007

(ABOVE RIGHT) ROADSIDE SHRINE, BLAJENII DE JOS, 2007

(OPPOSITE) COUNTRYSIDE NEAR BRAN CASTLE, BRAN, 1998

MANY OF THE PHOTOGRAPHS in this book are bleak, especially those showing the conditions of life in Romania after years of communist misrule. The photos I took in early 1990 to document the horrific treatment of abandoned children in hospitals and orphanages still make me cringe. Yet over the next two decades, as Romanian Children's Relief grew and evolved as a philanthropic organization, I found time to train my camera on what might be called the eternal Romania—the people and places that reflect the inherent beauty and character of this ancient and storied country. The photographs on this and following pages are some of my favorite images on my travels in Romania. They by no means represent a complete portrait of the country geographically speaking for there are still many areas I have not visited. They are my visual memory of a world apart.

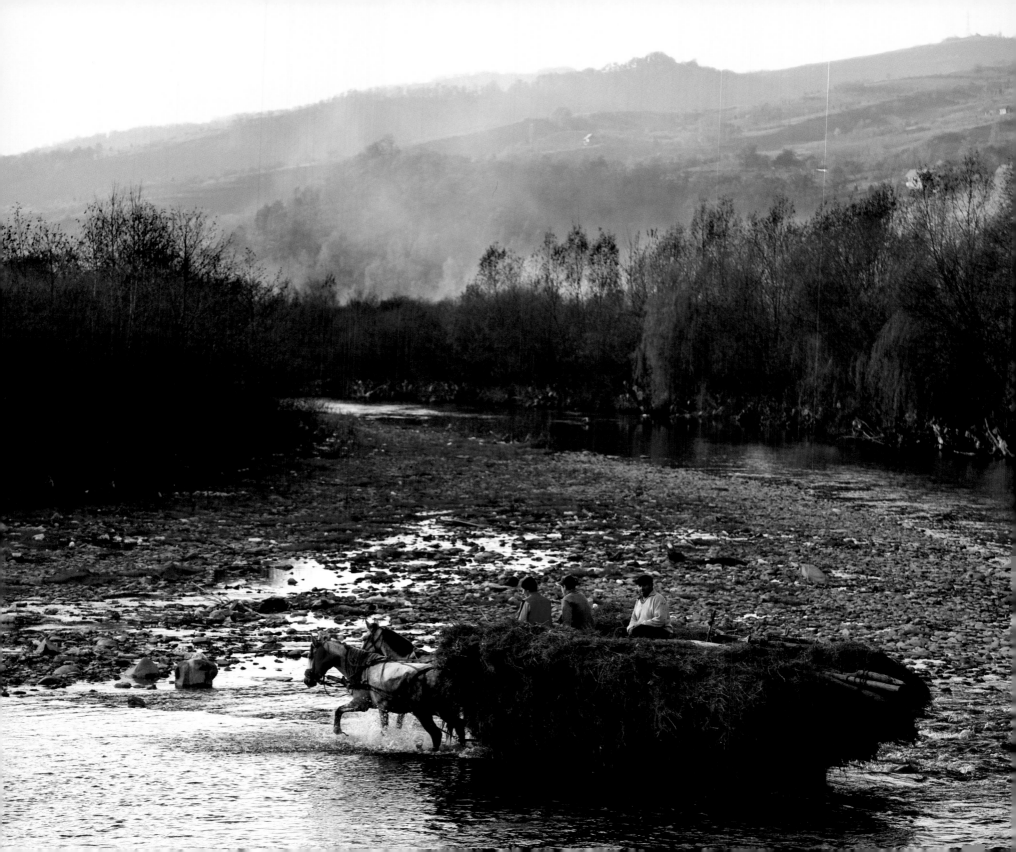

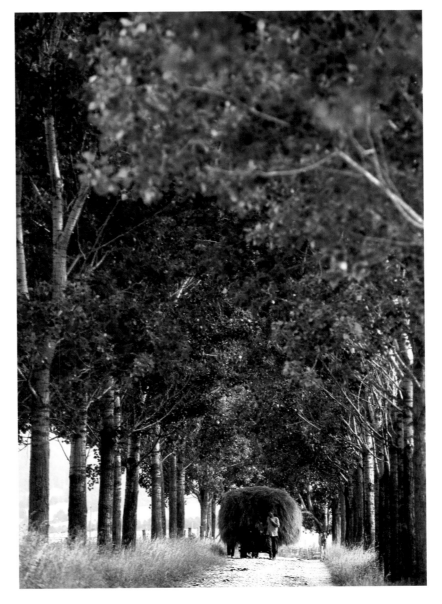

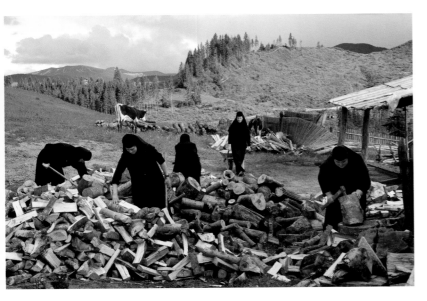

(TOP) ROMA QUARTER, BISTRITA, 2009

(BOTTOM) NUNS COLLECT WOOD FOR MONASTERY,
PIATRA FINTINELE, 2005

(OPPOSITE LEFT) SOMESUL MARE RIVER, REBRISOARA, 2006

COUNTRY LANE NEAR RISNOV, 1999

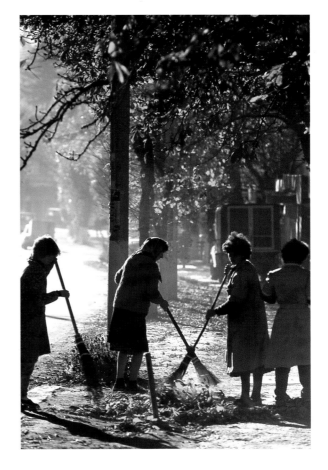

CHRISTMAS ON LIVIU REBREANU
BOULEVARD, BISTRITA, 2008

STREET SWEEPERS, CIMPINA, 1998

LIVIU REBREANU BOULEVARD, BISTRITA, 2006

120

(TOP) POTATOES BOUND FOR FARMERS' MARKET, BISTRITA, 2001

(BOTTOM) DACIA, PEOPLE'S CAR DURING COMMUNIST ERA,
BISTRITA, 2001

(TOP) CATTLE HOMEBOUND, DUMITRA, 2008

(BOTTOM) SHEEP GATHERED FOR MILKING, MURESENII
BARGAULUI, 2008

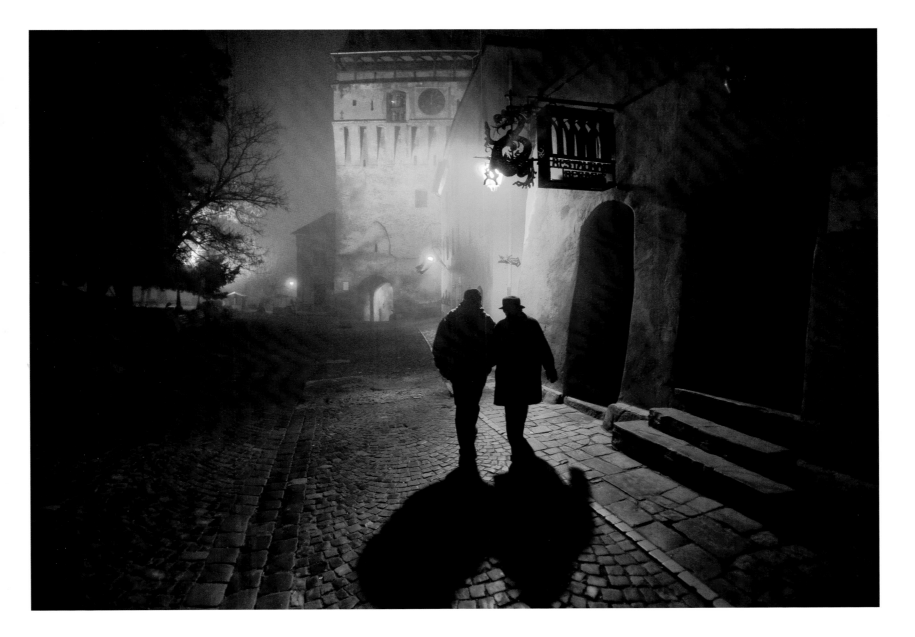

SIGHISOARA, 12TH-CENTURY GERMAN FORTIFIED CITY,
BIRTHPLACE OF VLAD III (DRACULA), 2006

VARIATIONS ON A THEME: ROMANIAN ORTHODOX CHURCHES
IN TRANSYLVANIA

(TOP) CIRLIBABA, 2007

(BOTTOM) COZANESTI, 2006

PRISILOP PASS, 2006

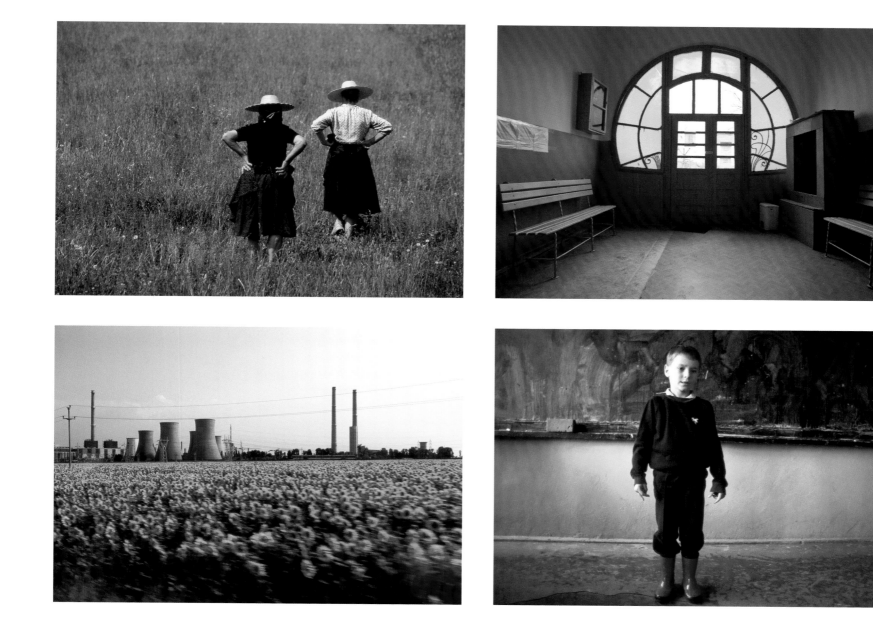

(TOP) WOMEN IN FIELD, SINTEREAG, 2003

(BOTTOM) CROP OF SUNFLOWERS NEXT TO POWER PLANT
OUTSIDE PLOIESTI, 1997

(TOP) MEDICAL CLINIC WAITING ROOM, BUCSANI, 2008

(BOTTOM) SCHOOLBOY, BUCHAREST, 1995

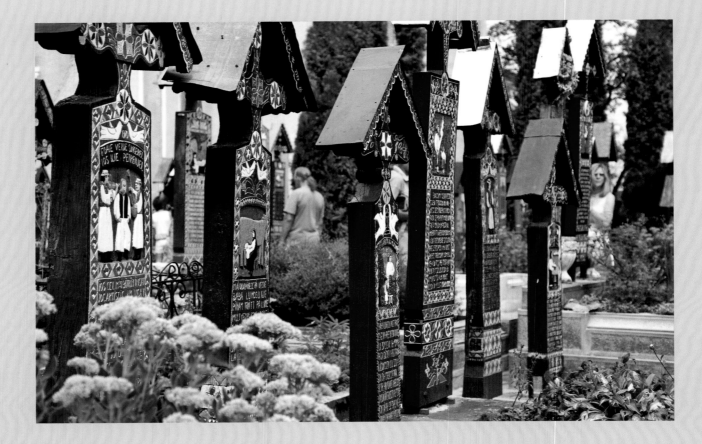

Merry Cemetery

ONE DAY, after concluding some RCR business in Bistrita, Joan and I embarked on a daylong sightseeing trip through the mountains in the north of the country near the border with Ukraine. We were determined to visit an unusual graveyard someone had told us about, located in the town of Spanta. Set foot in it as we did, and you know at once why it is called Merry Cemetery. There are some six hundred graves, all marked by carved wood headstones depicting in whimsical fashion the circumstances of the death of the person buried beneath, as the accompanying photos show.

A certain shepherd's death, for instance, is blamed on a murderer from Hungary who "hacked my body clean asunder and I was buried six feet under." Another headstone depicts a man being run over by a taxi whose driver the victim would like to see "burn in hell."

The tradition of carving epitaphs that describe and illustrate how local folk met their untimely ends evidently began in 1935, the brainchild of a wood-carver in town named Ion Stanpatras. It is carried on today by other local carvers. Not surprisingly, the cemetery has become a tourist attraction.

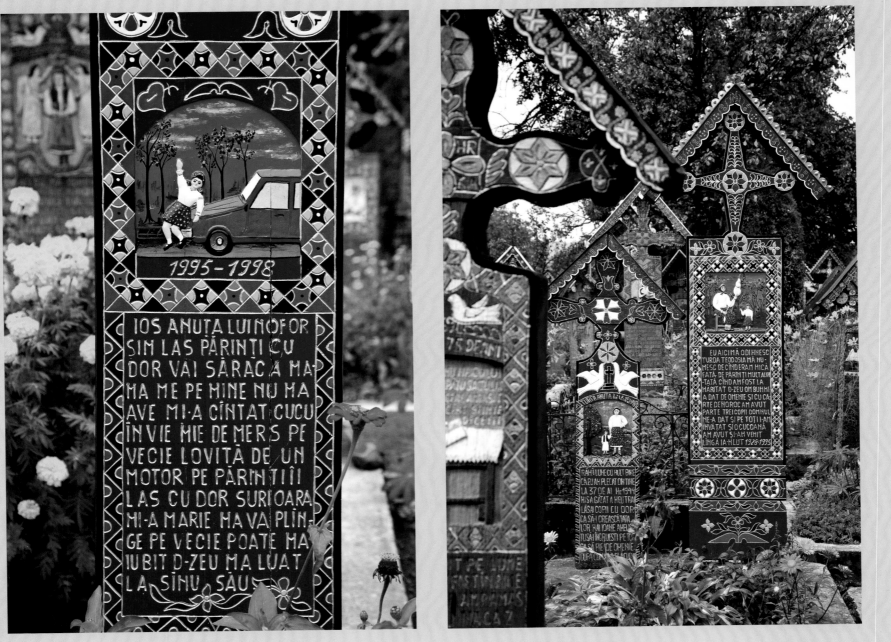

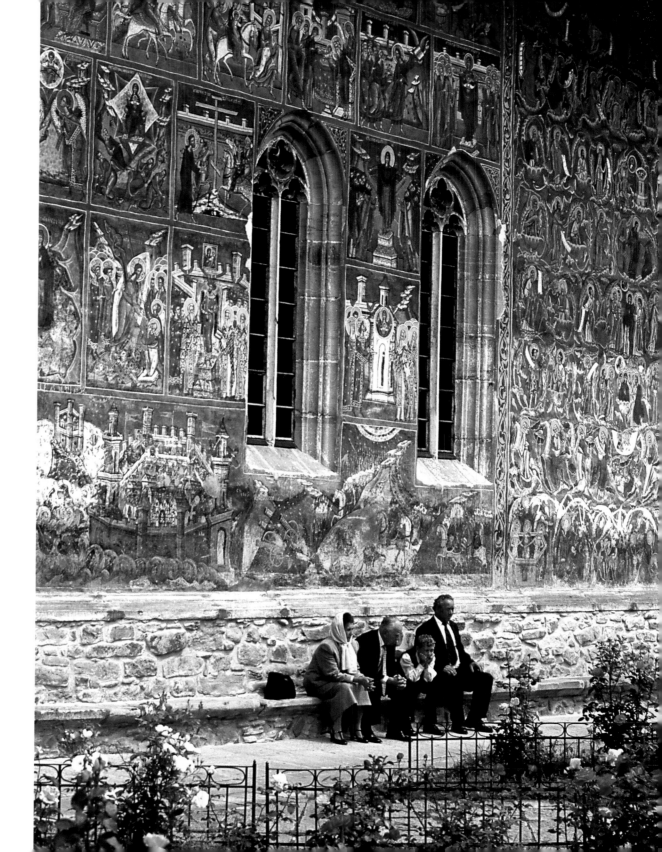

CHURCH OF SAINT GEORGE OF THE VORONET
MONASTERY, BUILT IN THE CENTURY BY
STEPHEN THE GREAT, GURA HUMORULUI, 2001

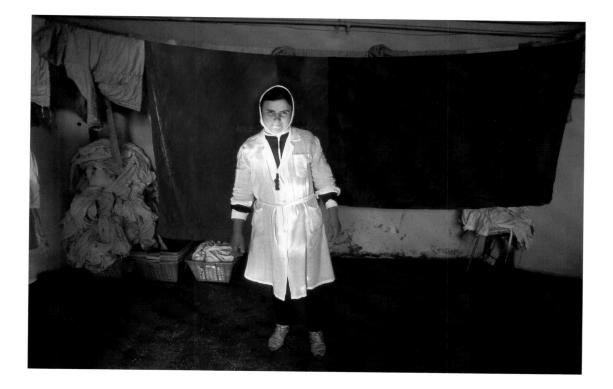

(TOP) LAUNDRESS, ORPHANAGE NO. 4, BUCHAREST, 1994

(BOTTOM LEFT) PEASANT WOMAN, GHINDA, 2002

(BOTTOM RIGHT) COUPLE HAYING, REBRISOARA, 2007

CHILDREN, BISTRITA, 2009

CHRISTENING, BISTRITA, 2005

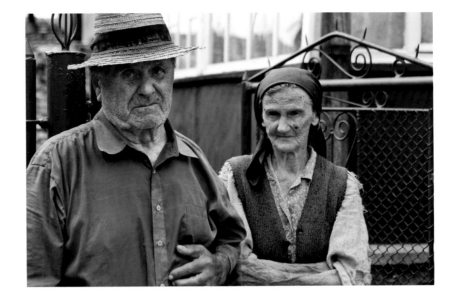

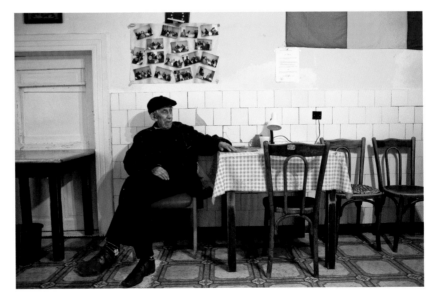

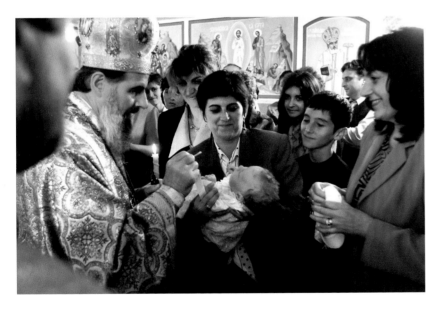

(TOP) DANA WITH EARLIER PHOTOS OF HERSELF, BOSENAGU, 2008

(BOTTOM) CHRISTENING AT PLACEMENT CENTER, FORMERLY
AN ORPHANAGE, BECLEAN, 2003

(TOP) HUNGARIAN COUPLE, NIMIGES DE SUS, 2006

(BOTTOM) OLD-AGE HOME, BISTRITA, 2008

GROCERY STORE SHOEHORNED INTO A BUILDING ERECTED AT THE END OF THE CEAUŞESCU ERA, BISTRITA, 2007

OLD CITY, BISTRITA, 2000

(TOP) CHENTURA, RING ROAD AROUND BUCHAREST, 2009

(BOTTOM) SOLDIER ON DUTY AT ARCUL DE TRIUMF, BUCHAREST, 1994

18TH-AND 19TH-CENTURY ARCHITECTURE, BUCHAREST, 2008

CARUL CU BERE RESTAURANT, BUCHAREST, 2009

(TOP) NEIGHBORHOOD STORE—STANDARD FARE, BUCHAREST, 2008

(BOTTOM) STAND OFFERING POPULAR MEAT DISH, *MITITEI*, 2006

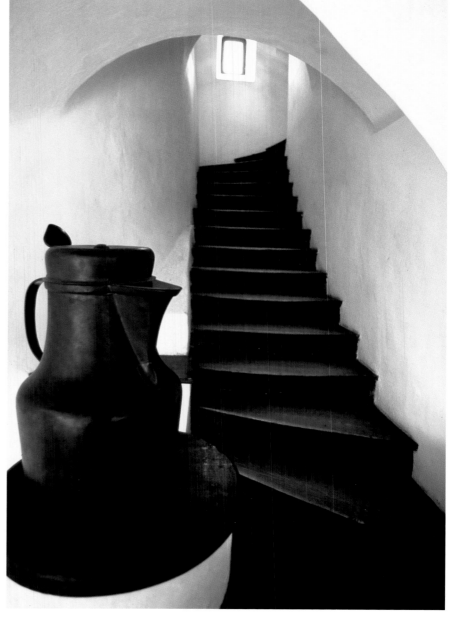

(TOP) GAMBLING CLUB, BISTRITA, 2006

(BOTTOM) WEDDING BOUTIQUE, BUCHAREST, 1997

STAIRWELL IN BRAN CASTLE, BRAN, 1995

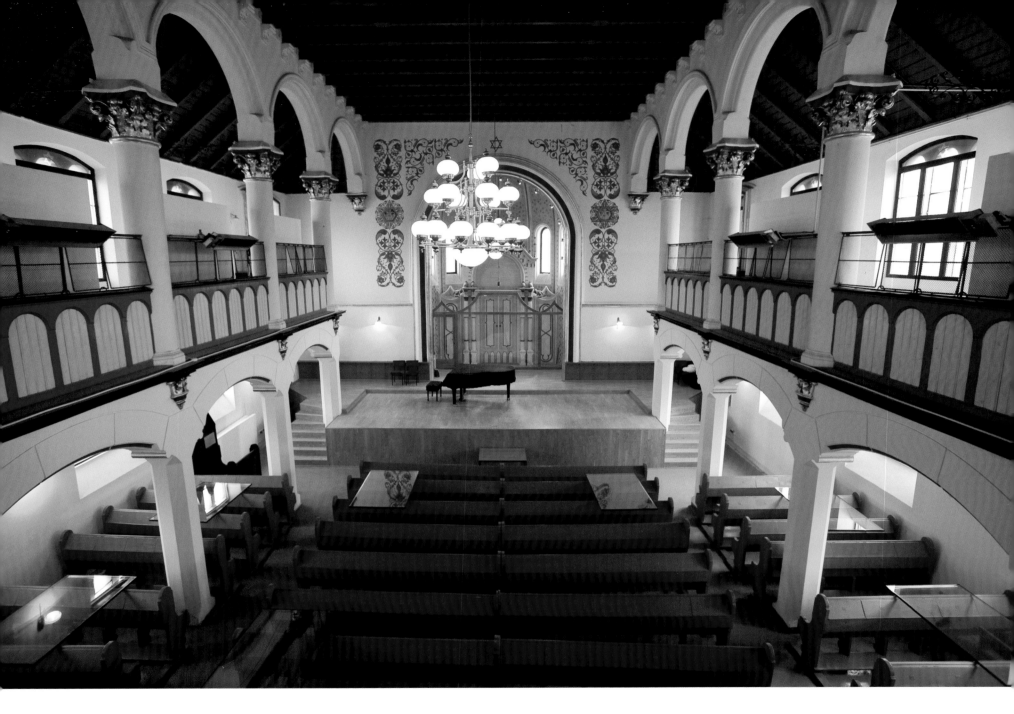

FORMER SYNAGOGUE RENOVATED AS ARTS CENTER, BISTRITA, 2007

SHEEPHERDER NEAR BRAN, 1998

APARTMENTS, NASUAD, 2008

CARPATHIAN MOUNTAINS LOOM OVER VILLAGE, RECE, 1997

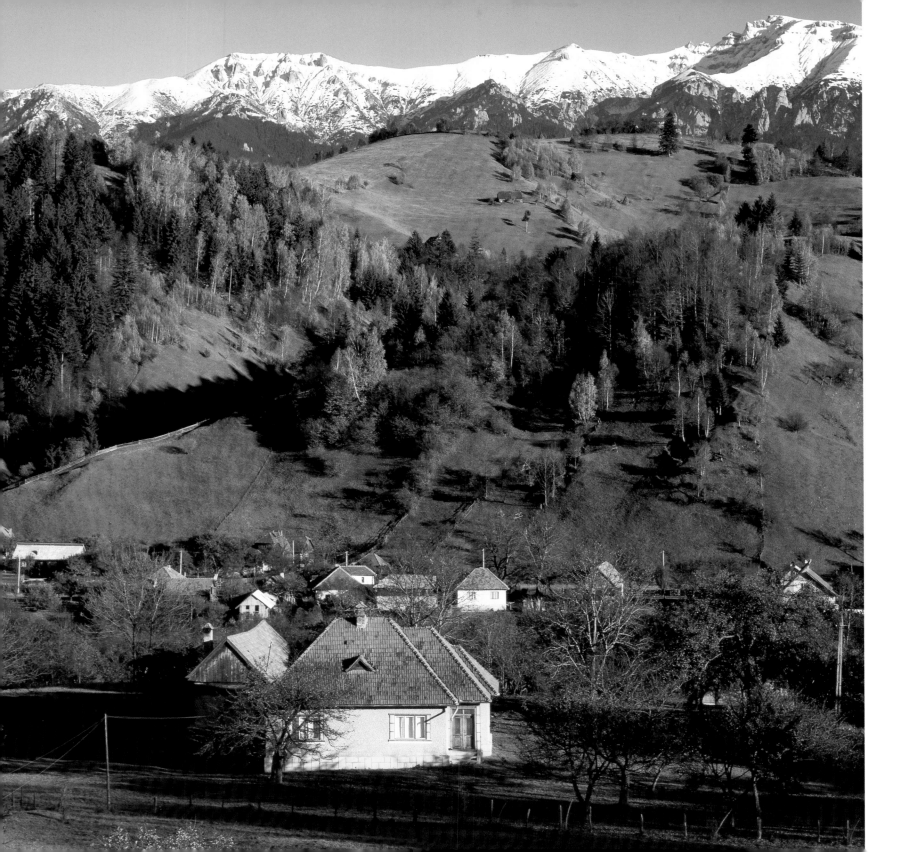

Epilogue

AFTER BEING CHECKED OUT for smoke inhalation on the day of the three-alarm "structure fire" that almost did me in, I got back from the hospital in Ayer at about 1 p.m. (I was billed $500 for the ride in the EMT truck, incidentally.) I was wearing Bermuda shorts and a green hospital smock, which proved to be my only surviving wardrobe at the time.

Joan had rushed to the hospital from an education conference in Harvard, and drove us home. Our son, Brendan, who had ignored speed limits on his way from his place in Worcester, was standing in the driveway, traumatized. As were we all.

Some of the volunteer firefighters were still on the scene, but the fire had been extinguished. Yellow crime-scene tape encircled the barn building. We would not be allowed entry until arson investigators from the state police had completed their work. The barn's cement siding was intact but badly scorched. All the windows were gone, and the ground was littered with glass and other debris. The stench of carbonized wood and plastic hung in the air.

Broad puddles of water were everywhere.

Even before getting inside, I knew my studio was a lost cause. All my computers, my Hasselblads, my lenses and tripods, my lighting equipment, were history, melted and smelted by the intense heat of the blaze. But that was not the extent of the damage. Dark smoke had rolled in copious waves from the burning barn building through the connecting ell and into our house. And the smoke had reached into every nook and cranny of the residential quarters. All the clothes hanging in our closets and stored in our bureaus had been permeated by it and would cost thousands of dollars to clean. All the upholstered furniture was beyond redemption. Although we were able to reclaim some rugs, most of the textiles and fabrics we had acquired over the years could not be saved. We were by no means serious art collectors, but we did have favorite pieces on our walls, some of them executed by artist friends, some of them my own photographs. These too were irreparably stained.

If it were not for the kindness of friends, I don't know how we would have survived this catastrophe. The rebuild-

ing and rehabilitation efforts would be extensive, and for four months we lived in a house across the street from ours, a rental property owned by my friend Mort. Settling with the insurance companies involved in the case initially was something of a nightmare, but one of the adjusters proved to be invaluable in resolving the claim on the house.

And look on the good side. We were all safe, including the parakeet, the cats, and the goldfish in our pond.

In the weeks that followed, Joan and I conducted meetings from Adirondack chairs on the front lawn with fire investigators, the fire marshal, insurance adjusters, and lawyers. Our outdoor office activities became a familiar sight in town. It would be several months, however, before I could resume the semblance of a business life.

As for my photo archive, a great deal of my original film was destroyed or compromised. A large percentage of it was saved thanks to the prompt intervention of the firefighters. But even that film had been coated with smoke and soot. It took Brendan and an assistant six months to clean and recatalog the sooty film.

I did manage to make good on my commitment to the Massachusetts Golf Hall of Fame. Although the golf prints

I had made that day had gone up in flames, Mike Nesbit, a photographer who has worked with me on numerous projects, had stored the same images on his computer and was able to download them. We had a New Hampshire lab enlarge, mat, and frame the images in record time. We delivered them to the hall of fame in time for the opening round of the Deutsche Bank Classic at the Tournament Players Club of Norton.

Many of my pictures from Romania were among the images saved. I can't adequately express the relief I felt when I discovered this. It was a stroke of luck, but it also seemed to me to be a kind of affirmation of our years-long efforts in behalf of the abandoned children of Romania. Restored to their original clarity after the fire, these images would live on to tell the story of the kids and our struggle to help them.

The fire taught me many things—the folly of complacency, the fragility of life itself, and the overriding importance of family, friendship, and love.

Just words—but sometimes words are all-powerful. Sometimes the word says it all. Sometimes a word is worth a thousand pictures.

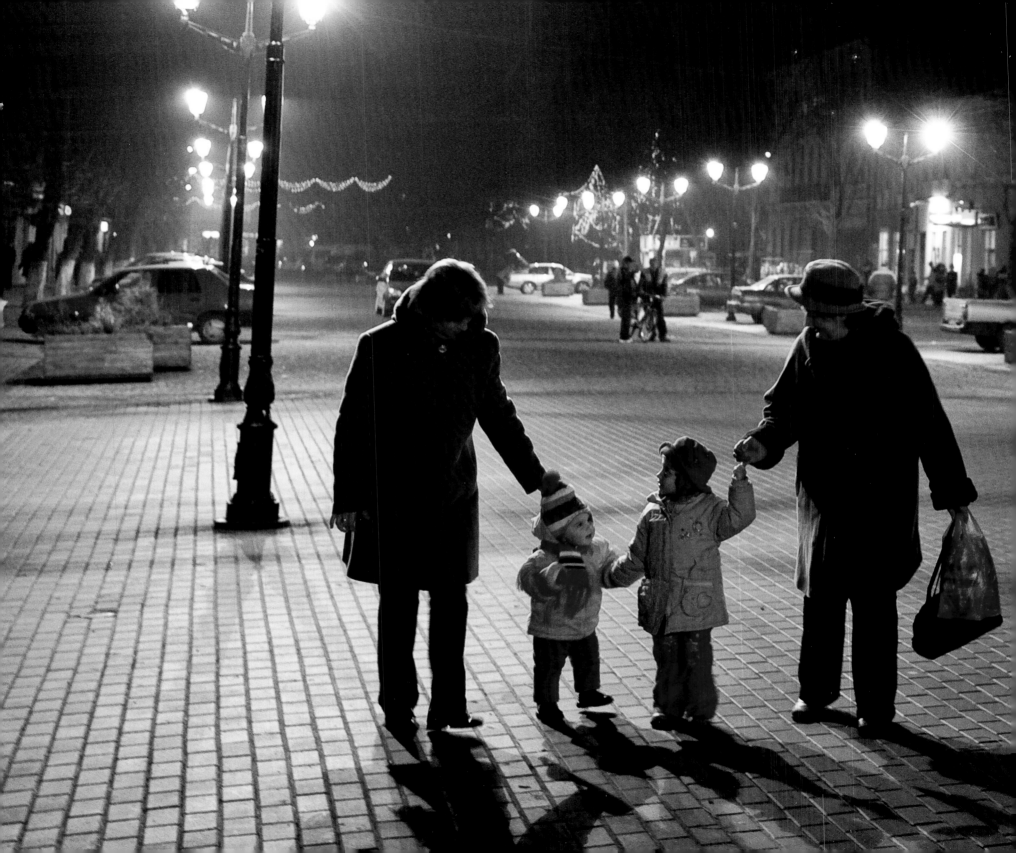

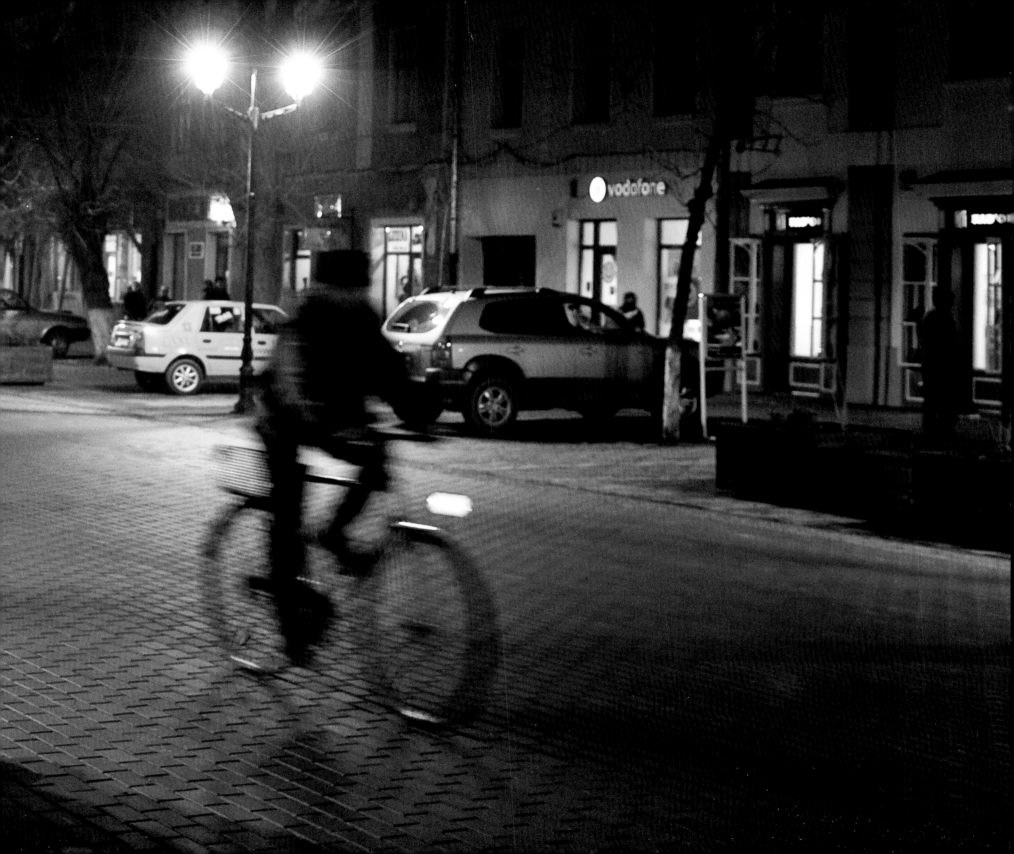

Acknowledgments

A RELIEF PROJECT is only as strong as the people who make it work. I'd first like to thank the incredible staff of Fundatia Inocenti and Romanian Children's Relief who have dedicated their lives to helping the children: Iuliana Tudor; Daniela Balan; Nicoleta Rosu; Stela Neagu; and Valentina Maghirescu, M.Ed. In Bistrita, our thanks go to Marin Mic, MSW; Alexandra Haliţă; Dr. Adela Cârcu; Maria Cioarbă; Romana Iepurean; Daria Ursu; Andy Barta; Răzvan Chirlejan; Ioana Săsărman; Andrada Miron; Maria Ott; Bianca Filip; Tiberiu Hunyadi, MSW; Tecla Ureche; Ildiko Coroi; and Natalie Bridges. Their work has made a huge difference in the lives of Romania's abandoned children, matched only by the foster families who have opened their homes and hearts to these children (special thanks to Sue Dwyer and family). To all of them, I say, *Multumesc*.

The Romanian Children's Relief/Fundatia Inocenti programs have been guided by several very talented in-country directors and managers over the years, including George Lang, Beth Bradford, Meg Harris Chung, Amy Conley, Carolyn Breed, Joyce Jung, Kim Kuehnert, and Sidney Elliott, who helped us turn the reins over to an all-Romanian staff headed by past directors Alice Conac and Laura Huzmezan.

Our staff members have always used teamwork in their approach to problem solving, and in doing so, have learned to rely heavily on our Romanian volunteers and partners. From Bucharest: Dr. Tatiana Ciomartan (also Vice President of Fundatia Inocenti), Dr. Adrian Georgescu, Dr. Alin Stanescu, Oana Clocotici, Dr. Raluca Ioan and Ecaterina Stativa, Beth and Avner Orshalimy, Irene Pirvu, Alexandru Conovaru, Oana Geambasu, Beth and Keith Kirkham, Monica Eremia, Elisabeth Gitenstein, Anne and Albert Roggemans, Osnat and Ady Hirsch, Mariana Lina, Loredana Groza, Ioan Vranceanu, Alexandru Icodin, Julianne Tobek, Gratiela Roventa, Dr. Mihaela Chiriac, Bogdan Simion, Roxana Maghirescu, Razvan Bordos, Sorin Basno, and Trust Team. From Bistrita: Flaviu Bercea, MSW (also on the Board of Fundatia Inocenti); Dr. Mircea Buta; Dr. Liana Rusu; Dr. Mihaela Masta; Monica Muresan; Cristian Tinis; Carmen Bulz; Gheorghe (Gigi) and Nicoleta Cherechesiu.

In the U.S. I need to thank those brave people who first joined us in caring for "Ceauşescu's children": Lisa Brodeur Stevens, Dr. Peter Massad, Jill Murphy, Dr. John and Pam D'Esopo, Sue Willing, the late Henry Poole, and Denise Noseworthy, and our volunteer Board of Directors: Dennis Irish, Linda McGowan, Jessica Bethoney, and Eileen O'Connell. Thanks also to our Advisory Board members: Dr. Betty Blythe, Bill Breidenbach, Terry Breidenbach, Dr. Jim Canfield, Patricia Carbery, Professor Gerard Clark, Kathleen Comfort, Dr. Amy Conley, Dr. Dana and Fred Floru, Wendy Gediman, Dr. Victor Groza, Valerie Hurley, Maureen Irish, Dr. Michael Kilian, Dr. April Levin, Diana L. Lorine, Amy Lynch, Sandra MacQuinn, Ed Madaus, Dr. Peter Massad, Dr. Laurie Miller, Dr. Matthew Panagiotu, Dr. Camelia Rosca, Dory Rourke, Mary-Gaines Standish,

Robert Stern, Pat Strong, Dr. John Sullivan, Hans Teensma, and Liliana and Dr. Marius Templer.

We've gotten a tremendous amount of support and the energy of youth from student groups from Tasis, the American School in England; Rivers School, Weston, MA (Susie McGee); Noble and Greenough School, Dedham, MA; St. Mark's School, Southborough, MA; The American School Paris (Jim Denison); the Franconian International School (Liam Browne); Case Western Reserve University; and Boston College Graduate School of Social Work. Students and interns who have made a huge contribution include Sarah Swett, Sayre McAuliffe, Stephanie Mann, Lisa Bossange, Kate Smith, and Andrea Schweitzer.

I can't emphasize enough the power of youth in completing a long-term job in a foreign country. People like Meghan O'Connell Kmetco, Cristian Jitianu, Lisa Mandelblatt, and Amy Lynch (and her mom, Diana Lorine, RN) have come along and brought new ideas when our organization most needed them.

Where would we be without donors? First, there was the Ayer Rotary; then the Rotaries in Boston, Worcester, and Framingham, MA; Paoli-Malvern, PA; Bistrita Nosa (Romania); and Esslingen Neckar (Germany); LIFT the Children (Katie Smith); Joyce and David Wagar (Mercer Island Rotary); Mimi, George and Katherine; Chris and

Marianne; Dusky Foundation; Frances, Gary, and Madeleine McCue; Linda Breneman; Ann Moorhouse; Margarite and Joe Landry; Mary D'Addario; and Peter and Mary Desy Bull, who have generously sent a gift every month, no matter what.

We've gotten some very professional help, from organization building to diplomacy and accounting, from Mo Boisvert; Linda Smith, Smith Sullivan and Co.; April Babbitt; and Professor Radu and Nicole Florescu.

The documentary *Hand Held*—and this book—inspired me to keep going and to do it like I'd never done it before. Thanks to Don Hahn, Connie Thompson, Larry and Carol Sheehan, Chris Jerome, and Hans Teensma (without whom I might never have gone to Romania).

Then there were many friends and family members—too many to mention here due to lack of space—who helped us along the way: Judy Clark, Jeff, Sandy, and Gary Cook, Roger and Lisa Goscombe, Bill and Kristin Mitchell, Gary Morton, David and Bobbi Spiegelman, Lee Aitken, John McNabb, Mark Zauderer, and Jen Druss.

I would like to especially thank our Executive Director, Eileen McHenry, for her enormous dedication and infinite patience, which have made the eighteen years of our collaboration both productive and enjoyable.

Thank you, everyone.

— M. C.

HAND HELD IS A DOCUMENTARY FILM PRODUCED AND DIRECTED BY TWO-TIME ACADEMY AWARD–NOMINATED FILMMAKER DON HAHN. IT TELLS THE STORY OF CARROLL, ONE OF THE FIRST PHOTOGRAPHERS TO TRAVEL TO ROMANIA AFTER THE FALL OF THE COMMUNIST REGIME IN 1989. HAHN SHOT IN BOSTON AND ROMANIA FOR NEARLY TWO YEARS ON HIS EXTRAORDINARY MOTION PICTURE ABOUT ONE GUY WITH A CAMERA, A BAND OF NEW ENGLANDERS, 160,000 ORPHANS, AND THE UNFORGETTABLE STORY OF HOW THEY CHANGED ONE ANOTHER'S LIVES FOREVER.

WWW.HANDHELDTHEMOVIE.COM

ROMANIAN CHILDREN'S RELIEF IS A 501(C)(3) CHARITY WWW.RCR.ORG WWW.INOCENTI.ORG